ZEN OF DRAWING

For Astor and family, with love.

First published in the United Kingdom in 2015 by
Batsford
1 Gower Street
London WC1E 6HD

An imprint of Pavilion Books Company Ltd

ISBN: 9781849941945

A CIP catalogue record for this book is available from the British
Library.

20 19 18 17 16 15
10 9 8 7 6 5 4 3 2 1

Reproduction by COLOURDEPTH, UK
Printed by 1010 Printing International Limited, China

This book can be ordered direct from the publisher at the website:
www.pavilionbooks.com, or try your local bookshop.

Acknowledgements
Many thanks go to Commissioning Editor Cathy Gosling and
Senior Editor Lucy Smith and their team at Batsford (Pavilion
Books) for their professional guidance and Albert Jackson for his
encouragement. My thanks go to Astor Parr for checking, numbering
and typing with such rigour and consistency.

ZEN OF DRAWING

Peter Parr

BATSFORD

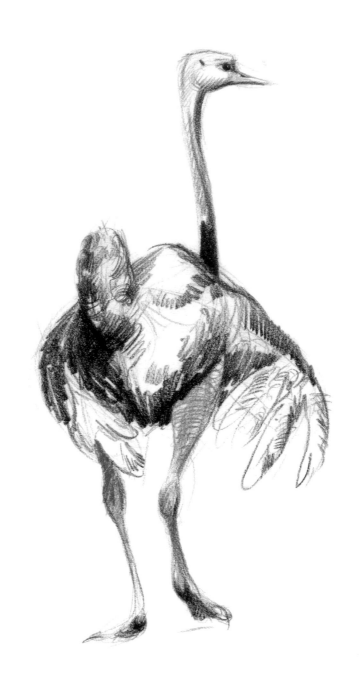

CONTENTS

INTRODUCTION 6

CHAPTER ONE – THE SKETCHBOOK 10
A sketchbook in the hand is worth two in the bag

CHAPTER TWO – NEW HORIZONS 24
A method of breathing and drawing fresh air

CHAPTER THREE – DEVELOPING
DRAWING SKILL 42
Speaking lines without words

CHAPTER FOUR – TOOLS 62
Finding the right tool for the job

CHAPTER FIVE – MARK-MAKING 112
Breathing sensuality and life

CHAPTER SIX – LIFE FORCES 134
The mountain imitates the dancer

CHAPTER SEVEN – MAKING A PICTURE 152
Rise to every occasion

CHAPTER EIGHT – A GROWING ARCHIVE 168
From the back to the front

INDEX 176

INTRODUCTION
HOW TO TAKE A PEBBLE FROM THE BEACH

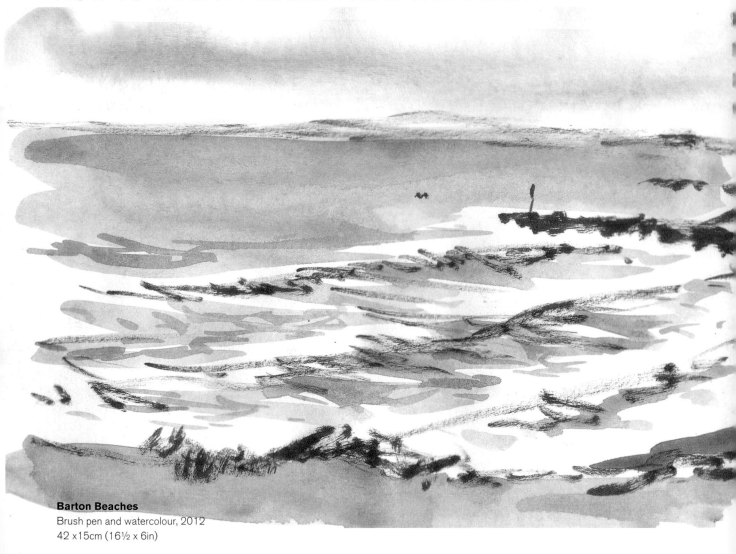

Barton Beaches
Brush pen and watercolour, 2012
42 x15cm (16½ x 6in)

17.11.11

Becton Bunny Beach
Black pencil, 1986
21 x 58cm (8¼ x 22¾in)

My aim in this book is to introduce you to a stimulating new approach to drawing that combines mark-making with inspiration taken from drama and dance. It will offer you a radical change in the way you look, think and draw, so I hope the book will encourage you to pick up a sketchbook and pencil and really go for it.

Today we live in a world of ever-decreasing attention spans and demands for high-speed responses which make it increasingly difficult for us to find the time to refresh our senses through observational drawing and reflection. However, if you are willing to create the necessary space, you will reap the benefits. In the following pages I would like to share with you the value that can be found by keeping a sketchbook: taking time out and stopping to consider, to look, and then to really see.

Many of the illustrations I have used were created spontaneously, catching a moment in time or made in a period of reflection. It has been my aim to encourage students to nurture their skills through observational drawing, and on many occasions they have said that my sketches look like finished artworks. Although the initial inspiration may have been something fleeting that caught my interest, my sketches are indeed finished artworks that now wait for their moment as inspirational reference in future projects.

The practice of gathering information, by first looking and then drawing, is always beneficial, no matter how or what you have gathered; your sketches will in some way inform and improve your skills.

Sketching is a pleasure; what I would call the ultimate experience of 'taking a pebble from the beach', but this new method of drawing leaves the pebble in place and untouched, while the captured sketch goes on to inspire your future work.

The reward and pleasure gained from engaging in the act of seeing and then drawing cannot be overestimated. So I invite you to collect your pencils, pens, paper or iPad and take part in a new and exciting way to draw.

Christchurch Old Mill
2B pencil, 1986
21 x 29cm (8¼ x 11½in)

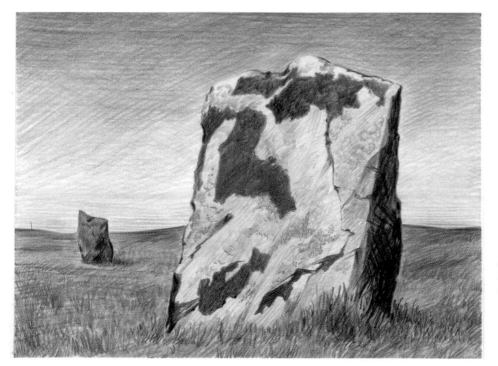

**Avebury, Wiltshire
Stone Circle**
Coloured pencil, 1986
21 x 29cm (8¼ x 11½in)

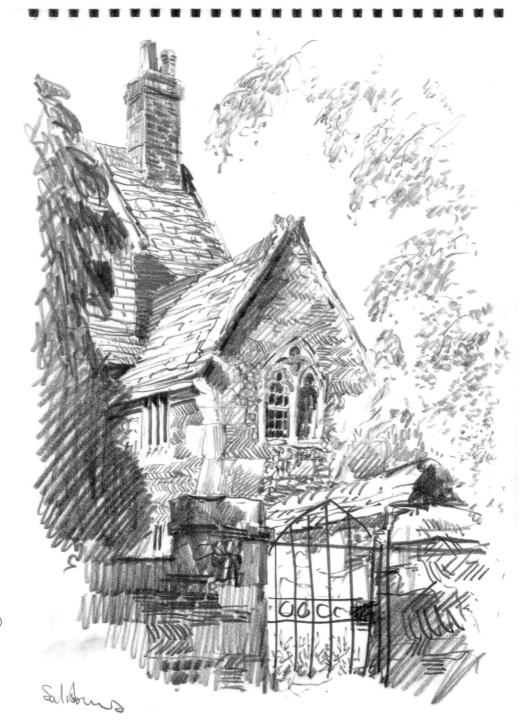

**Salisbury Cathedral
Close**
2B pencil,1986
21 x 29cm (8¼ x 11½in)

THE SKETCHBOOK

A sketchbook in the hand is worth two in the bag

This chapter will show how a sketchbook can become a travelling companion with which to share memories, or simply an archive in which to store your findings and meditations.

Back and forth went the chunky wax crayons clenched in little fists, making marks all over the paper – no time to stop, only to change colours again and again, densely layering the paper. Neither child could say what the marks were meant to represent, but neither did they care – they were just excited to have made a drawing.

Most children have had drawing books in which to tell stories, remember things or just play. Sadly, at the age of eight or nine they start to become dissatisfied with their drawings because they wrongly assume that they should be accurate representations of reality. What a mistake, for at that moment a very special instinct starts to wither and could eventually die. Those who survive this stage go on to become more confident in their ability to draw, making it a life-long hobby or even their way of making a living.

Photo Ciaran Parr

For centuries, both urban and rural environments worldwide have been marked with graffiti expressing someone's desire to be noticed and remembered: 'I was here!' This graffiti is from Gloucester Cathedral and a forest oak.

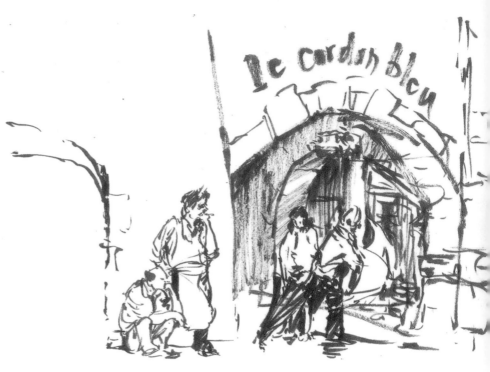

Mark-making is a basic human instinct – our natural way to interpret or describe what we see, indicating that our senses are indeed alive and responding to our environment.

Whenever you're out walking, carry your sketchbook in your hand as this allows you to make an instant record of whatever catches your eye. Packed away in a bag, it is not really with you. It is the feel of the book in your hand, reminding you of its presence, that prompts your curiosity.

Each of your scribbles made, good or bad, will build the important stepping-stones that are so much a part of the creative process. Don't be tempted to tear pages from your book. A sketch should be kept, as it will almost certainly be used sooner or later, no

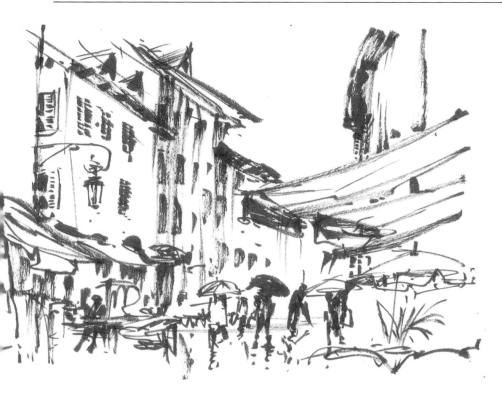

Annecy Old Town
Brush pen, 2009
21 x 58cm (8¼ x 22¾in)

matter how slight it may seem at the time. Its primary value to you was its creation –
an immeasurable benefit to your wellbeing.

My sketchbooks are a collection of drawings that keep me visually alert and up to
speed, in much the same way that actors rehearse or athletes work out to keep fit.
I can recall from them more detailed information than ever I can from a rapidly
snapped photograph.

Once my interest is caught and my eye alerted, I quickly and intuitively ask myself,
'What materials would best suit the subject? Should I try a new method of drawing?'
Then I cut to the chase and draw.

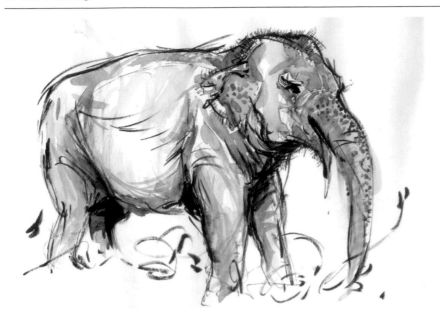

Decorated Elephant, Ahmedabad
Brush pen and watercolour, 2011
21 x 29cm (8¼ x 11½)
Note the weighty mass of this working elephant.

Sketchbook gallery – a random selection of sketches made from life in my sketchbooks.

Chilling out, Annecy
Brush pen, 2009
21 x 29cm (8¼ x 11½)
Here I took advantage of a relaxed life model for free.

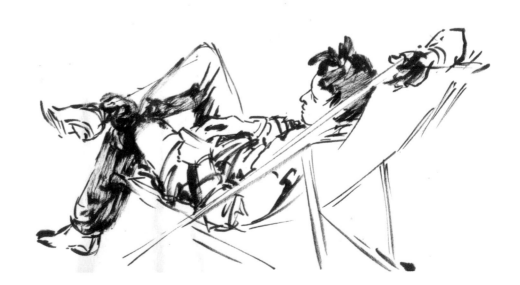

Farm Fowl
Watercolour, 2011
21 x 29cm (8¼ x 11½)
The humble farmyard chicken
can be just as interesting to
draw as a peacock.

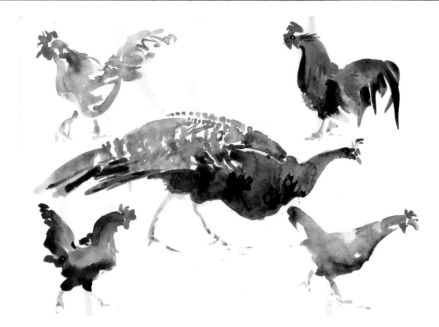

Spring Garden
Watercolour, 2012
21 x 29 cm (8¼ x 11½)
A garden in bloom offers the
chance for floods of colour.

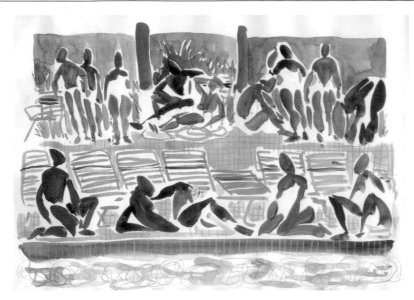

Fame City Poolside, Texas
Watercolour, 1986
21 x 29cm (8¼ x 11½)
Keeping a sketchbook to
hand encourages you to make
freestyle impressions from life
such as this.

Berlin Cathedral
Brush pen, 2010
21 x 42cm (8¼ x 16½in)
This sketch conveys the
architectural weight and energy
of an imposing building.

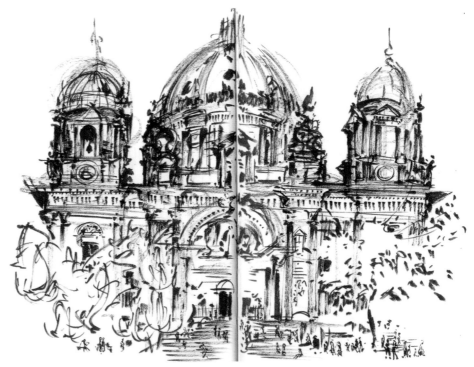

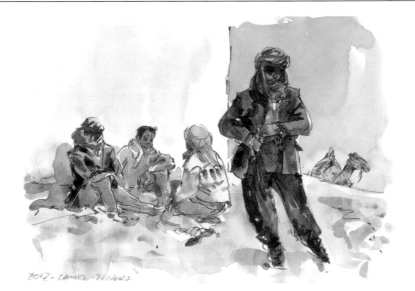

Camel Drivers
Watercolour, 2009
21 x 29cm (8¼ x 11½)
Here the dynamism of the
upright figure contrasts with the
more relaxed figures behind him.

Tunisian market
Brush pen and watercolour,
2009
21 x 29cm (8¼ x 11½)
A market is a good place to find
vibrant colour and activity.

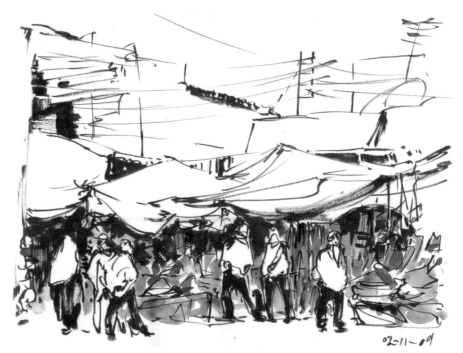

Byron
Pencil, 1981
21 x 13cm (8¼ x 5¼)
Surrounding dark pencil work
simplies the face.

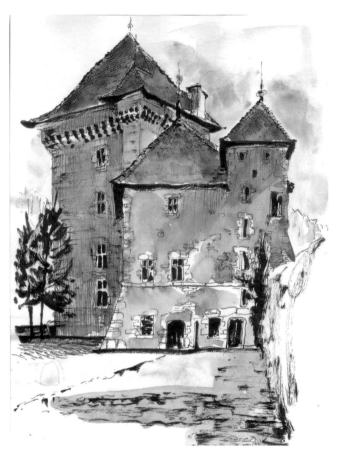

Annecy Castle
Brush pen and
watercolour, 2005
21 x 29cm
(8¼ x 11½)
Warm and cool
watercolour washes
enrich the stonework.

An open invitation No matter where I might be drawing in the world, it seems to be an activity that attracts attention. If I were writing in a notebook no one would try to read it, but an artist is considered to be fair game, offering an open invitation for public scrutiny. The most extreme example was at the Great Wall of China when a group of tourists flipped through the pages of my sketchbook as I was drawing,

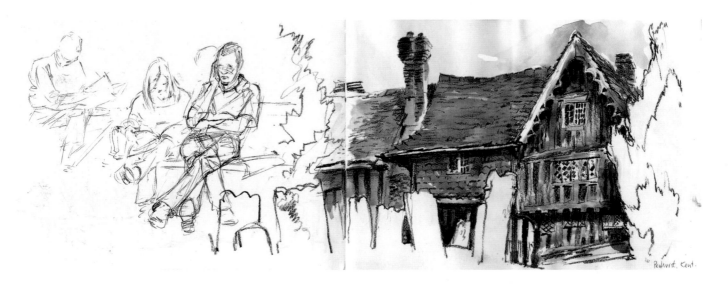

Penhurst, Kent
2B pencil and
watercolour, 2003
21 x 58cm
(8¼ x 22¾)
Here I was gathering
information on
people, architecture
and colours.

**Domes and
Crosses**
Pen, ink and
watercolour, 2010
21 x 29cm
(8¼ x 11½)
Small reference
studies are an aid to
finished paintings.

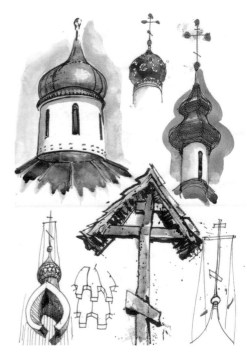

and then with polite nods of the head moved on. Over the years I have become immune to this kind of attention and so I just carried on drawing regardless. It can be daunting for an inexperienced artist, but try not to let it put you off – the interest shown is usually well-meant.

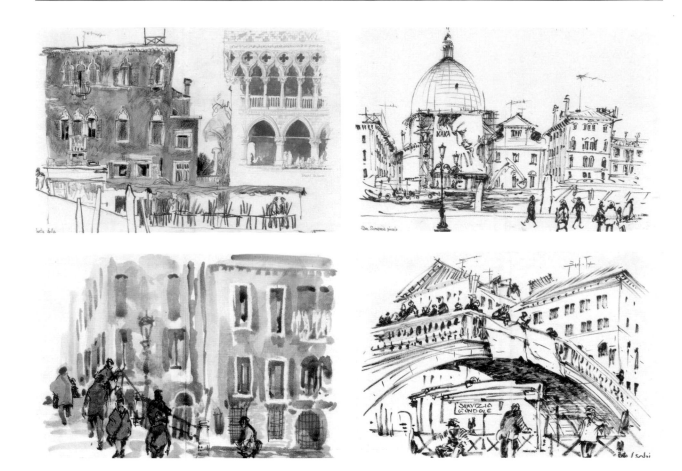

Trying out a concertina sketchbook for the first time, I thought it would be fun to create a collection of sketches that could unfold like a scroll, 3m (10ft) long, to record my three-day visit to the Venice Biennale in 2007.

Your sketchbook can become a place in which to broaden and preserve your drawing progress, building a resource that will inform your work. It will become a treasury of

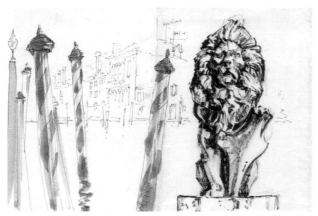

This compilation of sketches is presented in the order that I drew them in my foldout concertina sketchbook.

memories and playfulness, which can lead you to discovery and fulfilment in your drawing. The fact that you have a sketchbook and use it regularly to observe, draw and have fun is a testament to your commitment to finding your path as an artist. I guarantee that once you have formed the habit of using a sketchbook you will feel lost without one.

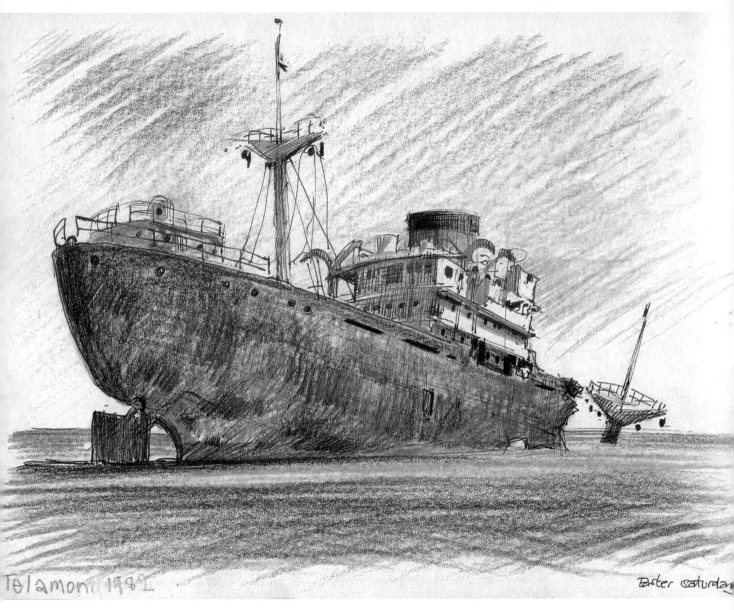

Telamon 1992

Easter saturday

Telamon
Fine point and Caran d'Ache, 1992
21 x 29cm (8¼ x 11½in)

NEW HORIZONS

A method of breathing and drawing fresh air

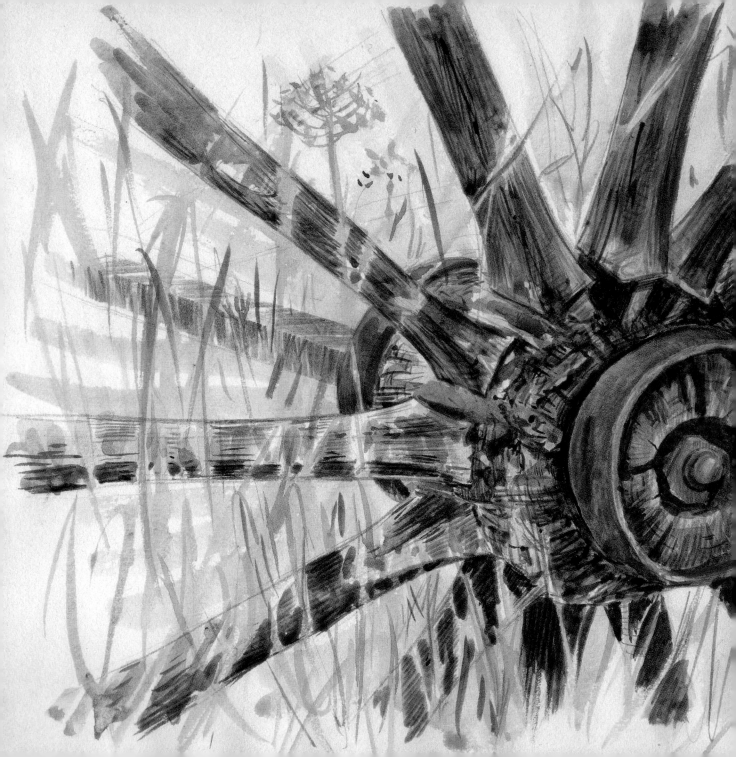

This chapter opens up a new approach to drawing by combining breathing and timing in much the same way that musicians, actors and dancers employ timing in their form of art.

Even in speech and writing, we use phrasing as timing. When we draw, we can recognize timing by feeling the way we apply our mark-making. This encompasses all marks without exception, not just one type of mark.

This abandoned wheel hub in a far corner of a field had resigned itself to its fate after many years of hard work. Its noble sun-dried skeleton and rusting iron axles amid the wispy bleached grass caught my attention.

Time spent quietly observing and drawing is a gift beyond price.

Wheel hub
Watercolour, 1986
21 x 29cm (8¼ x 11½)

Done Cruisin'
Coloured pencil and
watercolour, 2012
21 x 29cm (8¼ x 11½in)
History, material and decay cry
out to be drawn.

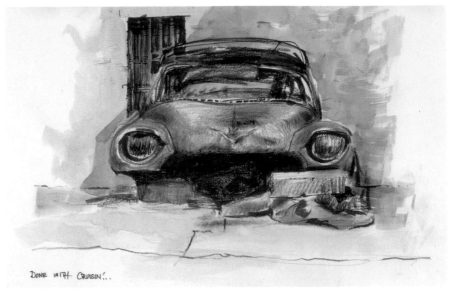

Old Ted
Pencil, 1980
29 x 21cm (11½ x 8¼in)
Here my 2B pencil mapped the
surface of the fabric.

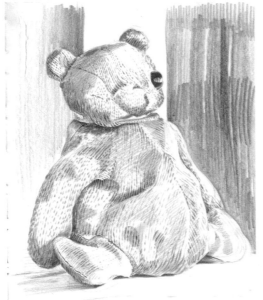

Timing controls and focuses our breathing with intent.
Therefore when we draw, we can deliver a considered inner
response in preparation for a meaningful outer action in
drawing. If we don't manage our inner attitude to our drawing,
how can we be expected to interpret what we see? When we
draw it is our aim to provoke a reaction from within, so that
we can communicate with our subject in a way that will enrich
our attitude to drawing and life as whole.

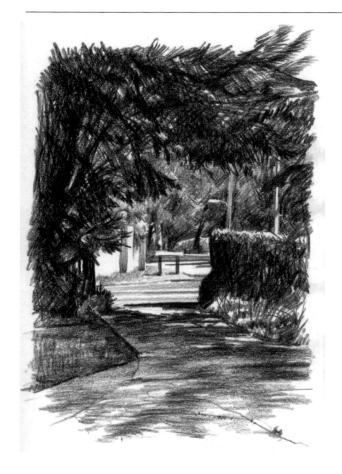

Sunlit Driveway
Coloured pencil, 2013
29 x 21cm (11½ x 8¼in)
The rich, dark texture of the trees intensifies the sunlight.

Our body is the conduit through which we allow ourselves to engage with our subject to experience its attraction, its life, and its continuing narrative. I believe this inner journey is of great significance to my method of drawing.

Once our senses are stimulated by an object we see, we can engage what actor/director Constantin Stanislavski (1863–1938) called our 'emotional antennae'. We all use our emotional antennae when we meet someone for the first time; we look them straight in the eye and follow with a quick body scan, before returning to their eyes in an attempt to discover more about them. Likewise, when our emotional antennae are alerted by an object they begin to channel details to our inner eye for distillation before we draw its shapes and textures on paper.

Consider, then, these theories when they are applied to drawing. They enable our eye, brain and hand to draw what we see in a very distinct way. The act of drawing becomes a new experience, which engages our senses as we share a communion with our subject.

Vineyard Wood Pile
Pencil and watercolour, 1986
29 x 21cm (11½ x 8¼in)
A study of time, exploring the fissures and textures of ancient wood.

Marabou Stork
Quill pen and watercolour, 2010
42 x 29cm (16½ x 11½)
Dynamic economical lines seize his alert pose and focused interest.

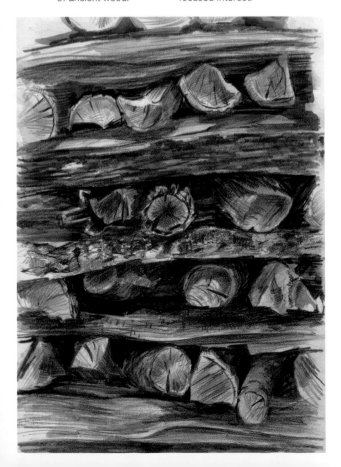

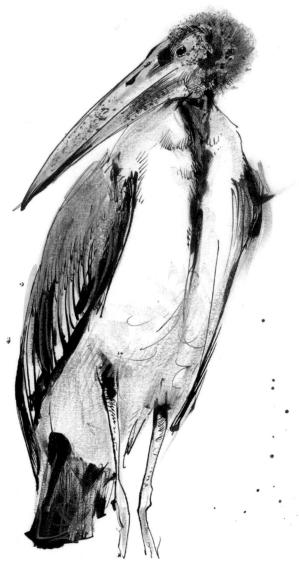

Russian Wood Cutter
Brush pen and watercolour,
2010
21 x 29cm (8¼ x 11½in)
Conserving of the single
maker's craft.

I begin by applying these ideas, to control the way I use my drawing instrument to make a wide variety of sensitive marks, achieved substantially by modulating the amount of pressure I apply in order to interpret what I see, and interpret from nature.

Here, in my drawing of a fallen oak tree, my pencil lines replicate and retrace the ancient journey made by the growing sapling, as its branches reached out for a space in which to mature through centuries of good and bad seasons.

Fallen Old Oak Tree
2B pencil, Sept 1995
19 x 25cm (7½ x 9¾in)
Here my pencil transcribed history's meandering form.

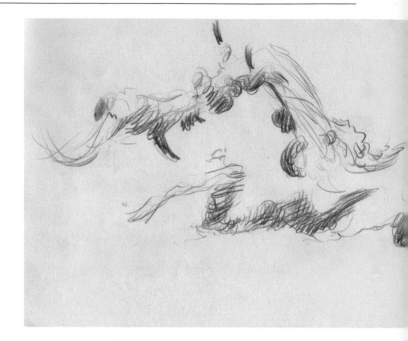

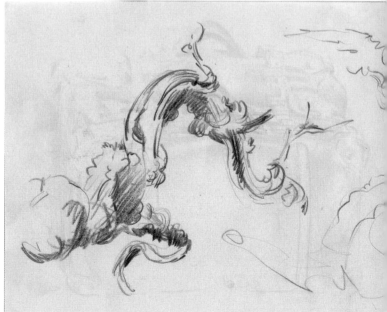

Doomsday's Acorn

Three hundred years of twisting and turning from seedling to sapling; then rounded maturity.

Three hundred more spring times, summers, autumns and winters; before three hundred years dying.

In life you witnessed twenty-seven generations of man and now, in death, new generations can only imagine what you once were.

Now we see your hardwood frame, passed over by makers of the Fleet, arched against the forest floor, reluctant to make that final fall.

Now we read your ancient lineage by touch; a tactile reflection and closeness, before leaving with our lasting impression of your imagined history.

As children, we delighted in pretending to be superheroes, princesses, wizards and witches with our imaginary cloaks flying out behind us; arms outstretched, we would dive carefree through clouds of fancy. Today, competitions are held to find the best air guitarist or air conductor, the participants performing without instruments or orchestras. The winner is judged to be the person who can best imitate the actions to convince the audience that he or she has demonstrated real feeling and intention.

Movement theorist Rudolf Laban (1879–1958) recognized the importance of the actions made by performing artists and set out a system of notation to enable them to repeat those actions whenever necessary. His method was intended to help actors take

Artists realising their **Space** amd **Inner impulses** in preparation for **Outer actions**

Performing Arts Effort	Time – Scale Direct Actions	Visual Arts Mark-making
Pressing	Sustained Strong	
Gliding	Sustained Light	
Thrusting	Sudden Strong	
Dabbing	Sudden Light	

control over their bodies in order to focus their minds. He named these movements 'Efforts'. An awareness of the Efforts enables the artist to express their space, in which to realize Weight and the duration of Flow (speed mark making). To empower the quality of our awareness we should use the Efforts in conjunction with varying Time scales, such as sustained, strong, sudden, light, direct or indirect actions unique to the visual artist. Realising Space equates to looking at your subject to understand its volume and character before materializing it on paper.

Here I have added a column to Laban's notations to translate Efforts into mark-making, where artists realize their inner impulses in preparation for outer actions – drawing.

Performing Arts Effort	Time – Scale Indirect actions	Visual Arts Mark-making
Wringing	Sustained Strong	
Floating	Sustained Light	
Slashing	Sudden Strong	
Flicking	Sudden Light	

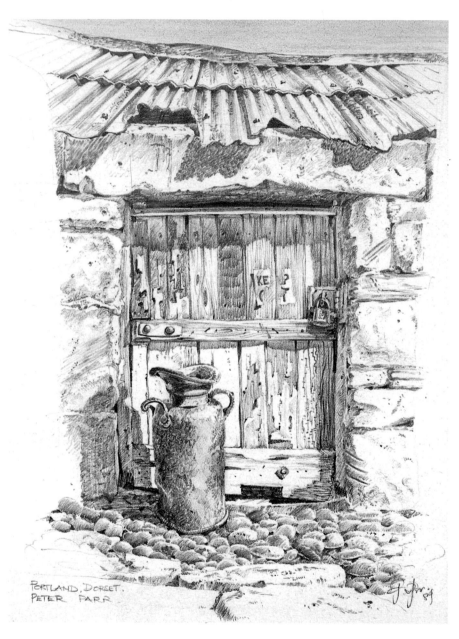

PORTLAND, DORSET.
PETER FARR

Fisherman's Cottage, Portland
2B pencil, 1989
28 x 21cm (11 x 8¼in)
By permission of David & Nicola Evans

Although visual artists have a different outcome to the performing artist, we share a common bond in the preparation of our inner attitude before delivering an outer expression. It's about being aware of our reflexes as they alert our inner attitude to modulate our outer actions. By varying modulations of our drawing instrument, both sustained and light or with direct actions that are sudden and strong, the marks we can make are refreshingly different in character, each defining the varied surfaces and textures of our subject.

Look at my drawings *Fisherman's Cottage, Portland* and then *Orangutan*; such different subjects, and as you examine them, imagine how I might have changed my inner attitude in order to perform my outer actions in a way that interprets the nature and character of my subject.

Orang-utan
2B pencil, 1999
28 x 21cm (11 x 8¼in)

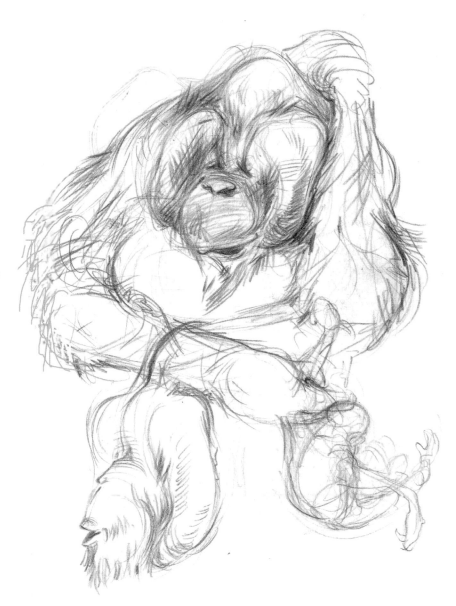

Fisherman's Cottage, Portland speaks of rusting corrugated-iron roof sheeting; hewn blocks of weathered etched stone; the stout oak door and the battered milk churn. Listen to the pebbles under foot and finally feel the warm sunlight making subtle reflective shadows, without which the image would lack form!

To describe the orang-utan's anatomy, my 2B pencil made gentle circumnavigations of his bulk before making stronger strokes in and around his limbs to suggest undulating silky lines that create the modelling of his furry coat.

This method of drawing provides me with a tactile experience of my subjects, imbuing the act of drawing with a new lease of life. As for me, I am refreshed by my shared closeness with my subject.

Summer Garden
Coloured pencil, 2013
29 x 21cm (11½ x 8¼)

1. FLICKING TO PRESSING
INDIRECT TO DIRECT
LIGHT TO STRONG

2. THRUSTING
DIRECT, SUDDEN, STRONG

3. FLOATING
INDIRECT, SUSTAINED, LIGHT

4. FLICKING
INDIRECT, SUDDEN, STRONG

5. SLASHING
INDIRECT, SUDDEN STRONG

6. WRINGING
INDIRECT, SUDDEN, STRONG

7. PRESSING
DIRECT, SUSTAINED, STRONG

8. GLIDING
DIRECT, SUSTAINED, LIGHT

9. DABBING
DIRECT, SUDDEN, LIGHT

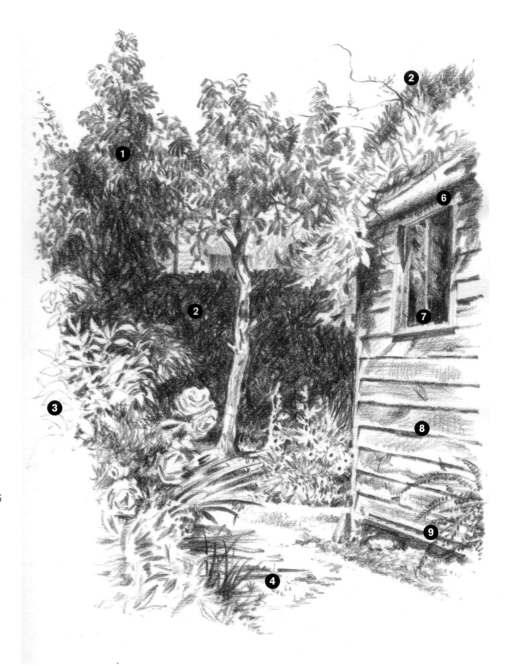

Garden fence
2B pencil, 1989
21 x 29cm (8¼ x 11½in)

In my drawings of a summer garden and garden fence I used my emotional antennae to sense my subject's surface textures. When you are drawing, try to experience and then interpret the lines and textures of every object you see.

The garden shed is drawn with light and sustained gliding strokes.

The dark hedge is heavily textured with strong, thrusting marks.

To draw the rich foliage I used a wide variety of lively efforts, from strong pressing strokes to light dabbing to flicking and floating textures.

Try to experience the sensual lines and textures of my drawings and then imagine how I 'felt' the marks physically and mentally as I drew them.

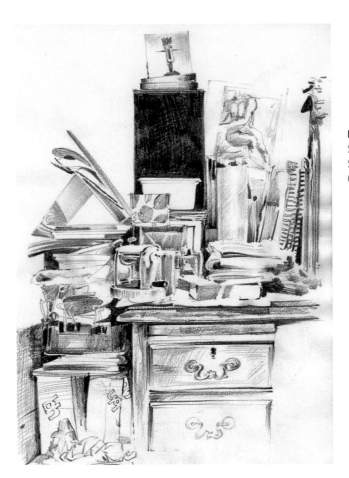

My Desk
2B pencil, 2000
21 x 29cm
(8¼ x 11½in)

Colobus Monkey
Coloured pencil, 2011
21 x 29cm (8¼ x 11½in)

My Desk shows a variety of surfaces from plastic and cardboard to wood and paper, with the black cloth of the radio speaker accentuating the white plastic container. In sharp contrast, the distinctive soft and silky hair of the colobus monkey defines her hunched but relaxed posture. My pencil lines imitate the experience of stroking her fur.

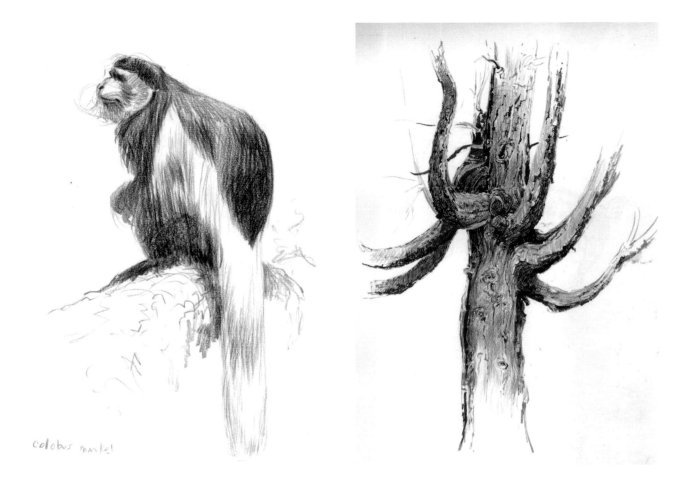

colobus monkey

Another change to my inner attitude was required to draw the splintery surface of the conifer bark, forcing my brush pen to snag and pluck at every twist and turn. I am excited by knowing that we have methods to interpret whatever nature has to offer, provided we prepare our attitude to respect and draw it.

Conifer Bark
Brush pen and coloured pencil, 2012
29 x 42cm (11½ x 16½in)

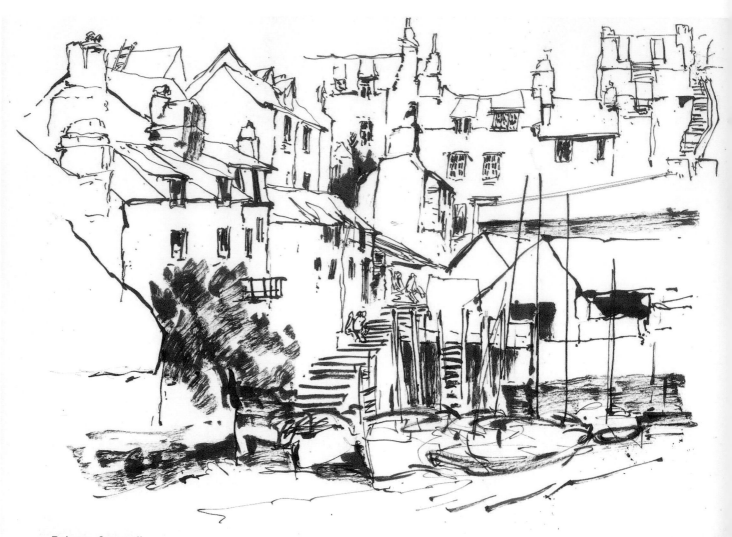

Polpero, Cornwall
Dip pen and ink, 2009
21 x29cm (8¼ x 11½in)

DEVELOPING DRAWING SKILL

Speaking lines without words

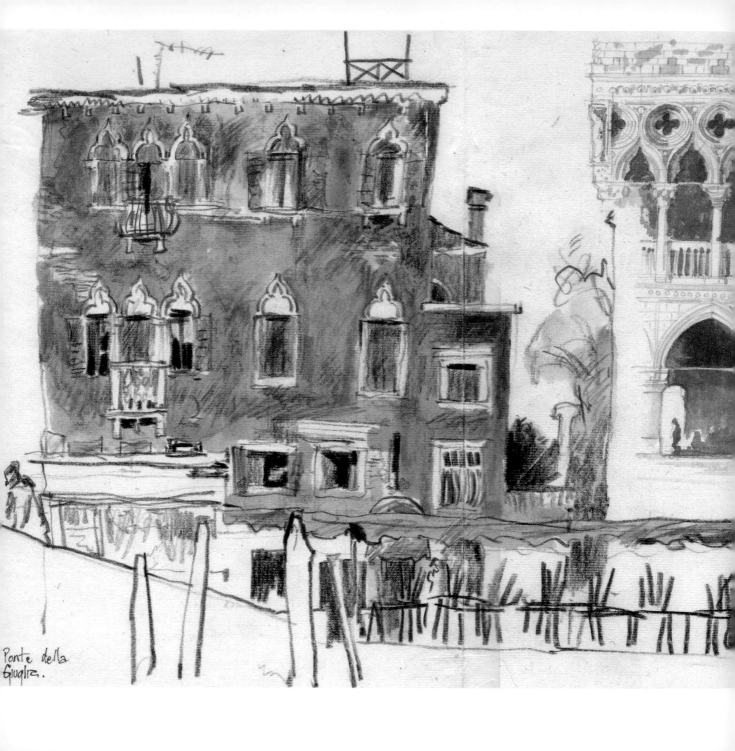

Ponte della
Guglia.

This chapter invites the reader to look at the work of other artists; to read and feel what it is that makes their work so enduring. It challenges our assumption that our memory is extensive enough to hold information concerning shape, colour and proportion and demonstrates why it can sometimes be advantageous to take a second look.

Ponte Della Giuglia and the Doge's Palace, Venice
Chinagraph pencil and watercolour, 2007
29 x 42cm (11½ x 16½in)

Venice is such a stimulating location for drawing – everywhere you look, there are subjects to exercise your mark-making techniques. This spread from my sketchbook shows two different styles of architecture and two different drawing methods. The crumbling red building was sketched with a chinagraph pencil, which combined a broken line with resistance to flooding watercolours. By contrast, the right-hand study of the Doge's Palace is a more precise pencil drawing with controlled watercolour detail.

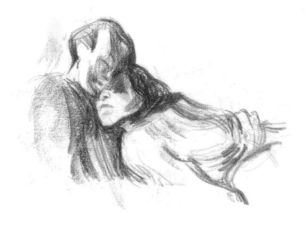

After Käthe Kollwitz
Conté chalk, 2000
21 x 29cm (8¼ x 11½in)
Soft and sensuously flowing
chalk marks describe the
two figures.

Ever since I developed my new approach to drawing, my research for a subject has begun by looking at how other artists apply mark-making in their work and then making my own observational drawings that are influenced by them.

Today, we no longer have the apprenticeship system in place where students were routinely expected to copy and learn from the masters. Sir Anthony van Dyck, court painter to King Charles I, was once chief assistant to Peter Paul Rubens; Leonardo da Vinci was apprenticed to Verrocchio and Degas to Ingres and so on.

Nevertheless, like many artists today, I make copies from the work of artists I admire which can lead me to discover new skills and working methods, giving me a greater appreciation of an artist and the materials he or she used.

After Brassaï (Gyula Halász)
4B pencil, 2001
21 x 29cm (8¼ x 11½in)
A sensitive composition of
minimal mark-making to
realize form.

After Rembrandt
Conté chalk, 1999
28 x 21 cm (11 x 8¼in)
A lively analytical observation of
anatomy and volume with tone.

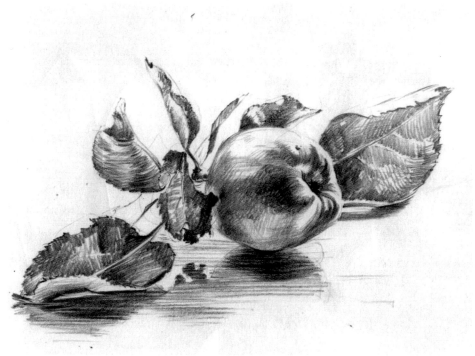

Copying your subject is not the same as reading it. Reading involves scrutiny – a close examination before you can interpret what you see with new life. Think of copying as a pupa and reading as the butterfly.

Fallen Apple, still life
Soft coloured pencil, 1989
21 x 29cm (8¼ x 11½in)

It is important not to slavishly copy the masters, but to read their messages as you draw. What might the line and texture do for the image? How does the line interpret light and shade to create volume?

Here three drawings show the differences in style between Käthe Kollwitz, Brassaï and Rembrandt. After studying their work, I followed up by making my own study from life using marks influenced by my readings.

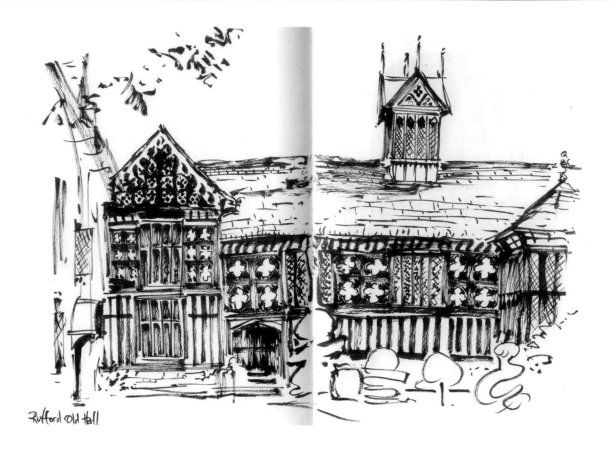

So, how do I know I have gathered information from my readings? My next step is to test what I have learned by putting my research readings into practice while I draw from life. If possible, do this at the same time as you make your own readings, as it is then easier to be influenced by your chosen artist.

I sat several metres back from the old timbered building to make this impressionistic sketch. My brush pen was the obvious choice for my rustic drawing performance as it can be used with great expression and speed.

Rufford Old Hall, Lancashire, UK
Brush pen, 2007
29 x 42cm (11½ x 16½in)
Here I made use of the tip and side of the drawing instrument.

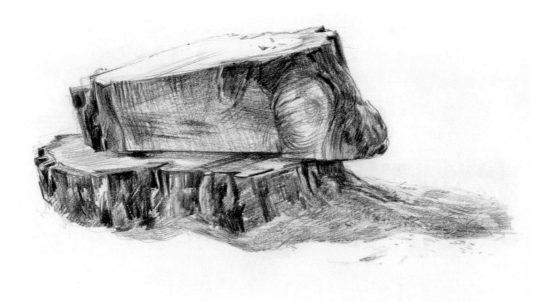

It was invigorating to sit just 2m (6½ft) from this pine stump, ready to focus my eye and powers of observation. I have drawn trees many times before, but this time it was different. To use every part of my being when I drew, I recalled Rudolf Laban's notation of efforts. The concentration was exhaustive, fulfilling and rewarding! The smell of the newly cut pine lingered in my nostrils for a long time afterwards.

By remaining the eternal student and reading the drawings of the masters, you will be rewarded by a strengthened ability to draw.

Sliced Pine Stump
Coloured pencil, June 2012
21 x 29cm (8¼ x 11½in)
Every dot, dash and stroke of the pencil sculpts the aromatic rough form.

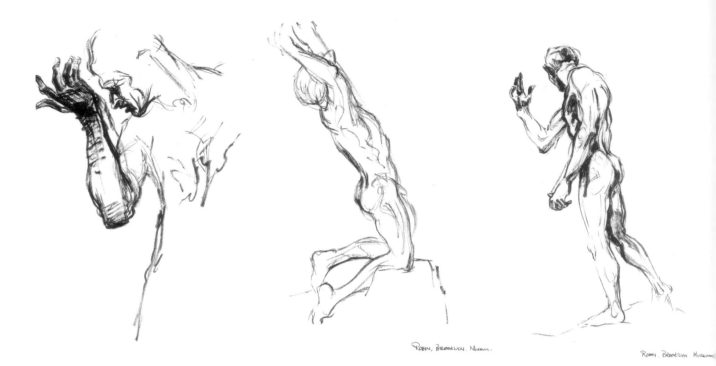

ROBIN, BROOKLYN. MUSEUM.

ROBIN. BROOKLYN. MUSEUM

To discover how my own personal drawing skill is developing, I often draw from sculpture for inspiration. Sculpture presents the new challenge of observing a subject in three dimensions. There are no lines surrounding the forms, only light and shade to define the subject.

Remember, these suggestions for study are not an instant remedy or a quick fix. The practice continues!

Drawing on memory
At this point, let us take a moment to consider the subject of memory and the part it plays when we draw.

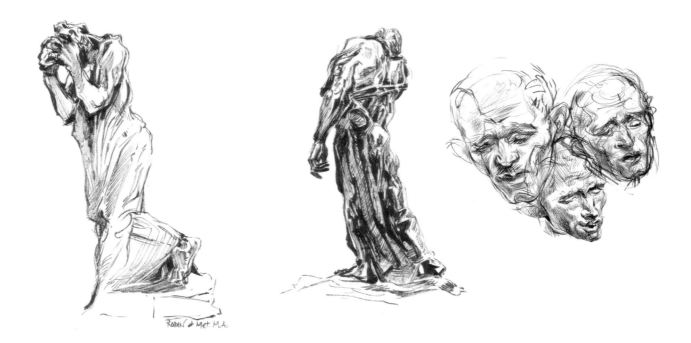

To make a drawing from life requires concentration and a great deal of memory. But why, if the subject is there to be seen? In making a drawing, there is a long journey to be made from seeing the subject, to drawing it on paper: a long enough journey for information to be lost, or at any rate, distorted.

When I work from imagination, I rely heavily on good research to reinforce my memory. However, a word of caution, from no less an artist than Leonardo da Vinci, in his Notebooks: 'Any master who should venture to boast that he can remember all forms and effects of nature would certainly appear to me to be graced with extreme ignorance, inasmuch as these effects are infinite and our memory is not extensive enough to retain them.' Who are we to argue?

Studies made from Rodin's Sculptures (above, left to right, 1–5)
Brush pen, 2006
29 x 21 cm (11½ x 8¼in)
Both the pens were worked ceaselessly to interpret the form of the sculpture with modulations and corrections that create a history of my drawing process.
Rodin Heads (above)
Dip pen and ink 2006
21 x 29cm (8¼ x 11½in)
All the studies were drawn in my A4 sketchbook.

Composition and colour

You can continue to develop and test your drawing ability in any number of ways when you are out sketching. If you must be quick, first set down the essentials and include brief colour notes and details. However, if time is on your side, celebrate the opportunity to put your materials to the test by making a more meditative study.

I respond to the format of my book before I balance my drawing on the page, giving all areas equal importance. The subject (positive areas) is supported by those areas in and around it (negative spaces) out to the edges of the page. When you begin a drawing it can be helpful to sketch out a frame to set up a tension across an otherwise blank page. After making a loose sketch to set up your composition, add detail to a specific area to mark your focal point: the all-important subject.

The French Market on Poole Quay, Dorset
Fibre tip pen and coloured pencil, 1997
21 x 58cm (8¼ x 22¾in)
These colour notes indicate the intense and complementary effects of light.

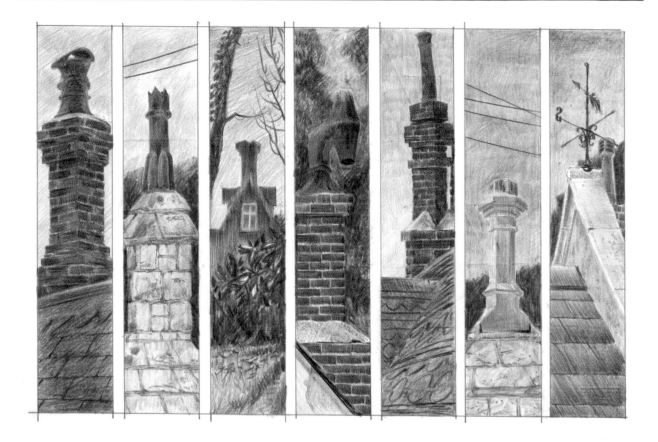

To explore the variety of materials used to build chimney stacks, I drew these seven studies, all within walking distance of each other. I saw the chimney stacks as having proud and distinctive personalities.

It was equally exciting to discover the variety and distinctive qualities of my coloured pencils as a drawing medium. Whether I was drawing stone, brick, slate, foliage or sky, with sensitive mark-making these pencils matched up to my demands. I could apply cross-hatched lines and also superimpositions of two colours that created a third optical colour – one that is blended by the eye.

Assorted Chimney Pots, Talbot Village, Dorset
Coloured pencil, 1987
35 x 24cm (13¾ x 9½in)
The pencil marks imitate the different surface textures.

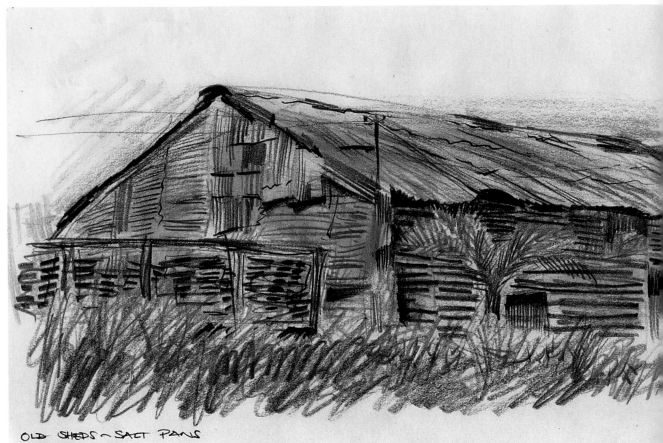

OLD SHEDS ~ SALT PANS
BUGIBBH.

I stumbled across this feast of textures – a wonderful assortment of wood and corrugated-iron sheeting in Malta. How does this building hold itself together? The sheds grumbled and groaned at the gentle breeze pushing through the fractured blades of the generator, causing them to creak and scrape eerily as I drew.

Salt Pan Processing Plant, Malta
Coloured pencil, 1996
21 x 58cm (8¼ x 22¾in)
In this drawing, it's possible to feel the efforts – weight, space, time and flow – in action.

Remember, carrying a sketchbook in your hand will stimulate your curiosity – a sign that you really want to draw!

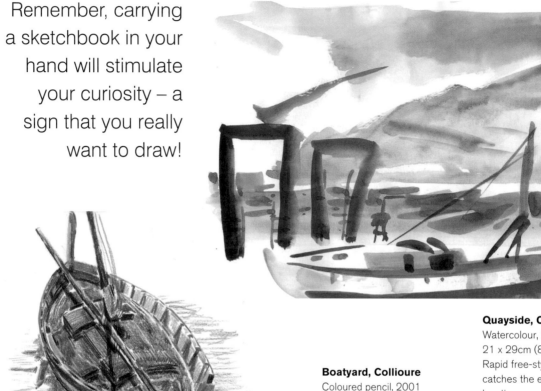

Quayside, Collioure
Watercolour, 2001
21 x 29cm (8¼ x 11½in)
Rapid free-style watercolour catches the essence of this location.

Boatyard, Collioure
Coloured pencil, 2001
21 x 29cm (8¼ x 11½in)
Here colour rather than detail is dominant.

This is Collioure in the south of France, birthplace of the colourful Fauvist Movement, where the influence that the ancient port exerted on the artists is everywhere to be seen in the houses, boats and sea. The location is liberating and the crystalline light makes the colours sing. Fortunately, on this occasion, I had my watercolours and coloured pencils with me. The atmosphere simply said, 'Go for it!'

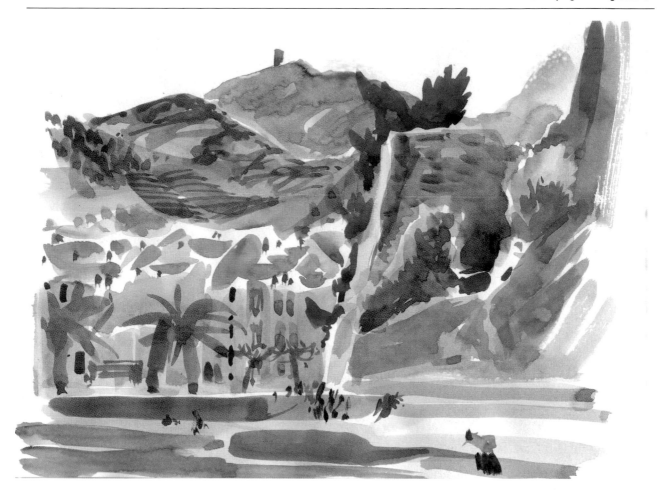

So, with all care thrown to the wind, I worked directly in watercolour without any initial drawing or concern for accuracy or detail. Colour was the inspiration and remained the inspiration for my drawing of the vibrant local fishing boat (bottom left), but this time I worked with coloured pencils to record the boatman's own bravado with a pot of paint and a brush.

Collioure
Watercolour, 2001
21 x 29cm (8¼ x 11½in)
Bright colour and sunlight describe the forms of the buildings and landscape.

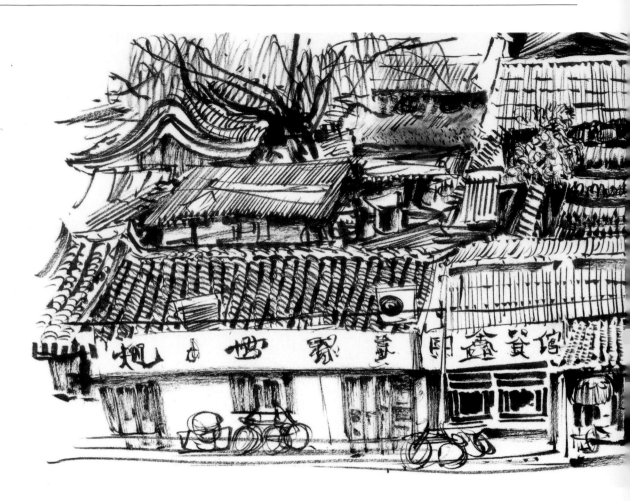

You may not think a brush pen would offer you much chance to apply Laban's notation of efforts to your drawing technique, but you only have to remember the strokes of the brush used by the Chinese calligrapher. It takes care, phrasing and breathing to deliver the desired mark; efforts such as dabbing (sudden and light), pressing (sustained and strong) and gliding (sustained and light) are all available to add freshness and variety to your work.

From my hotel window in Beijing, I had a bird's eye view of traditional alleys and courtyard buildings, known as hutongs. Taking advantage of this, I worked with a brush pen, seeking out patterns and textures. Amazingly, my wife recognized my Chinese calligraphy, which she translated as 'Chinese Dumpling Restaurant'. For my part, I drew only what I saw, which turned out to offer a delicious reward for taking the time to make a close observational reading.

The Hutong, Beijing
Brush pen, 2006
21 x 58cm (8¼ x 22¾in)
How many different marks can a brush pen make? Experiment to find out how you can use this drawing tool to the full.

My Studio Wall
Coloured pencil ,1990
21 x 29cm (8¼ x 11½in)
A sketchbook study drawing of
my pin board.

Whether you wish to draw in colour or monochrome, if you are looking for suitable marks to interpret what you see, Laban's efforts are there to add variety and freshness to your work.

Often solid and challenging reference is under our noses, but familiarity blinds us to its potential. I didn't travel far to find the inspiration for the drawing here. This is a sketchbook drawing of the pin board over my desk, which shows the collection of postcard reproductions and paper cut-outs taped to the wall. It offered me many opportunities to emulate the texture of each surface, reinvigorating my eye and powers of observation as I scrutinized my subjects.

Spider Webs

2B pencil, 1987

19 x 23cm (7½ x 9in)

Closely observed dark pencil
marks of the background create
the bottle and spider webs in
the foreground.

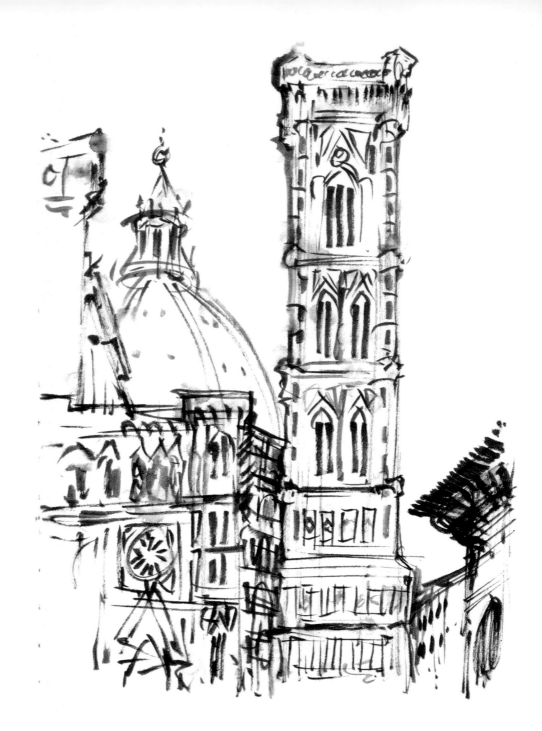

Giotto's tower
Brush pen, 2008
21 x 29cm (8¼ x 11½in)

TOOLS

Finding the right tool for the job

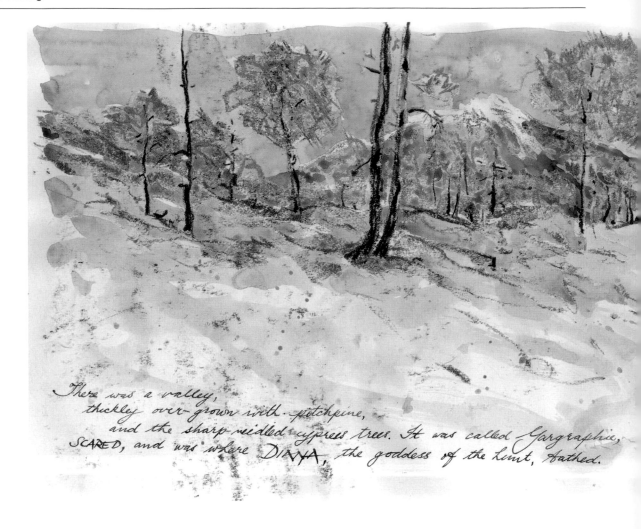

*There was a valley,
thickly over-grown with patchpine,
and the sharp needled cypress trees. It was called Gargraphie,
SCARED, and was where DIANA, the goddess of the Hunt, bathed.*

This chapter shows how both conventional and unconventional tools can produce surprising results. Try to carry tools with which to make a wide variety of marks, from pencils to an iPad.

The island of Tenerife is full of contrast. Successive volcanic eruptions from Mount Teide have created spectacular landscapes ranging from fields of lava to rich green plantations, black sandy beaches and dense pine forests. Whenever the opportunity to draw in such a dramatic environment presents itself, take full advantage of a box of drawing tools to re-energize your sketchbook.

Pine Forest, Tenerife
Oil pastel and watercolour, 2013
29 x 84cm (11½ x 33in)

My Cluttered Desk
Watercolour, 1994 21 x 58cm (8¼ x 22¾in)
My desktop clutter made an ideal subject for a
watercolour study.

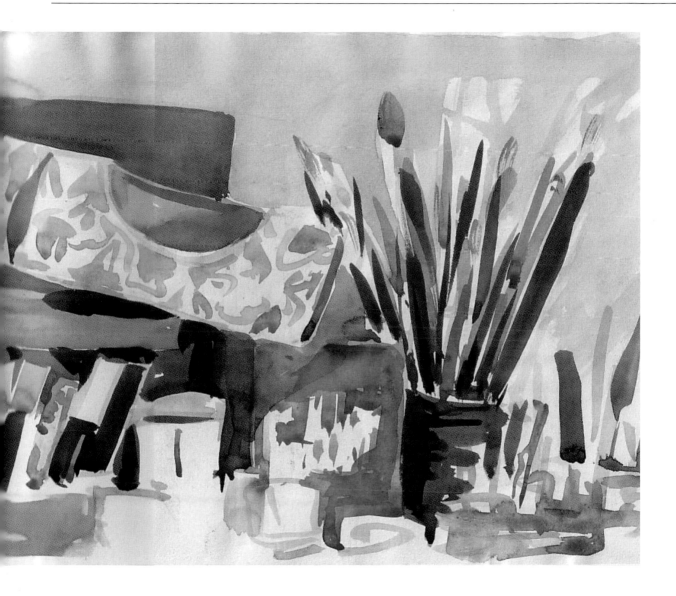

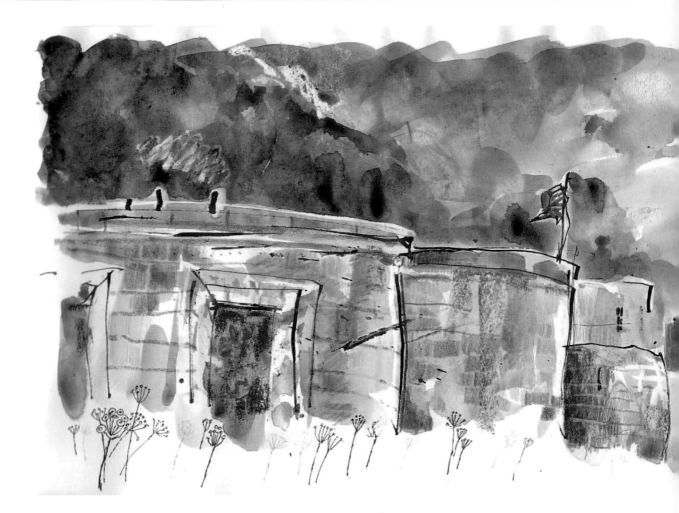

It is always exciting to anticipate a sketching trip, so I prepare a toolbox ready to make a wide variety of marks: pencils, pens and ink, paint and brushes or an iPad – implements to suit a specific purpose. As well as my conventional array of instruments, I like to add less conventional choices such as sisal string, twigs or quill feathers, which can add accident and surprise to my mark-making. I look forward to using such tools as they can be fickle and unpredictable as they celebrate their own life and spirit.

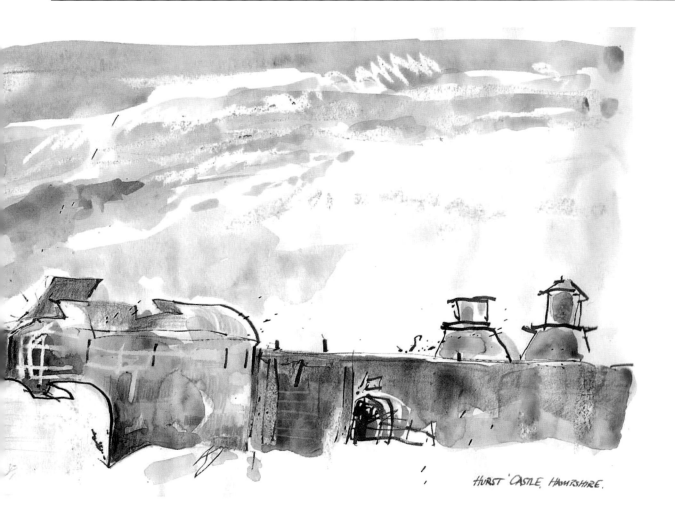

HURST 'CASTLE, HAMPSHIRE.

Hurst Castle, Keyhaven, England
Quill pen and watercolour with wax
resist, August 2011
21 x 58cm (8¼ x 22¾in)
This building is made of grey stone, but
it's invigorating to exploit your materials
and contribute your own colours.

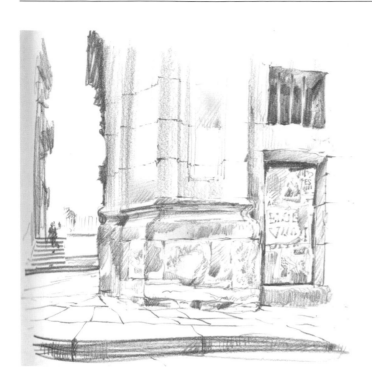

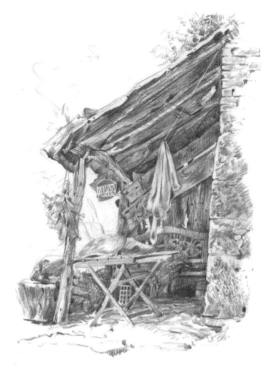

Tools of the trade: hard and soft pencils

These drawings show a variety of hard and soft pencil marks meeting a range of needs. Each surface texture requires a different effort of pencil mark to interact with your inner impulses and generate a variety of outer expressive marks when you draw.

It's important for me to find the time to stop and look, with the sole intention of refocusing my eye by making an intense observational study such as the bread oven or pot-bellied pig. Though this method of working takes all my concentration, it puts me back in touch with seeing and sensing, recharging my batteries.

Corner Stone, San Sebastian, Spain
2B pencil, 2002
25 x25cm (10 x 10in)
Dramatic differences in scale give interest and the soft pencil picks out the texture.

Bread Oven, Cortona, Italy
2B pencil, 2010
25 x 21cm (9¾ x 8¼in)
This is a prime example of an extensive range of mark-making.

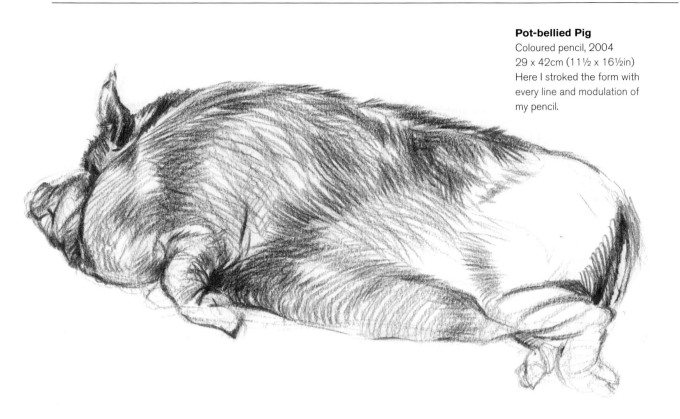

Pot-bellied Pig
Coloured pencil, 2004
29 x 42cm (11½ x 16½in)
Here I stroked the form with
every line and modulation of
my pencil.

Resting her broad cheeks on warm concrete was no doubt
bliss for this pot-bellied pig, spreading out her bulk
to feel the full warmth of the sun as she dozed.

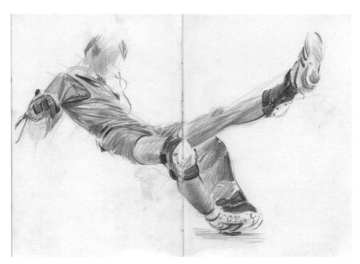 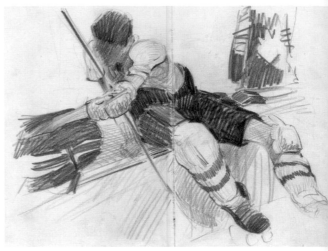

Skateboarder
Coloured pencil, 1987
21 x 42cm (8¼ x 16½in)
Here drapery describes
the form.

Ice Hockey Player
Coloured pencil, 1988
29 x 42cm (11½ x 16½in)
As I drew the visible front
of the figure I imagined the
invisible back.

Tools of the trade: coloured pencil

Make a practice of noticing the effects of light and colour on different subjects or locations. When you come to draw, coloured pencils can offer everything from direct intense colour useful for rapid note-taking such as these sports players to more considered and subtle studies.

I make trips to locations close to my home in England and return with sketches that will recall my day. From my drawing of the Cathedral Gardens, Salisbury, I can remember the heat bounced back from the brick wall behind my bench as I looked through the layers of trees towards the misty autumn light. Coloured pencils made the perfect choice to interpret the optical effects of this light. Two colours placed closely together will create a third colour: red and blue make purple, blue and yellow make green, and yellow and red make orange. Browns will neutralize any too-bright synthetic colours. To explore the benefits of coloured pencils, you don't need the light to be dazzling; it can be muted or subdued.

**Cathedral Gardens,
Salisbury, England**
Coloured pencil,1986
21 x 29cm (8¼ x 11½in)
Multi-layered colour adds
subtlety to light and atmosphere.

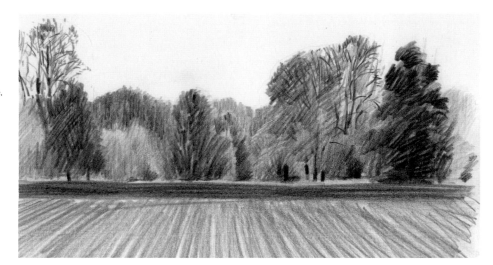

Café, Lanzarote, Spain
Coloured pencil,1992
21 x 29cm (8¼ x 11½in)
Sketching directly with colour
adds new possibilities with
luminous hues.

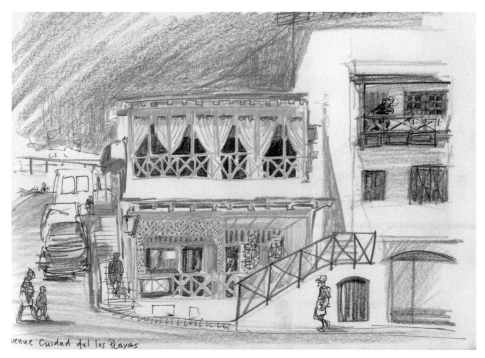

venue Cuidad del los Playas

Ostrich
Chinagraph pencil,
1995
42 x 29cm
(16½ x 11½in)
A sculptural use of
Chinagraph pencil
imitates the energy
of this bird.

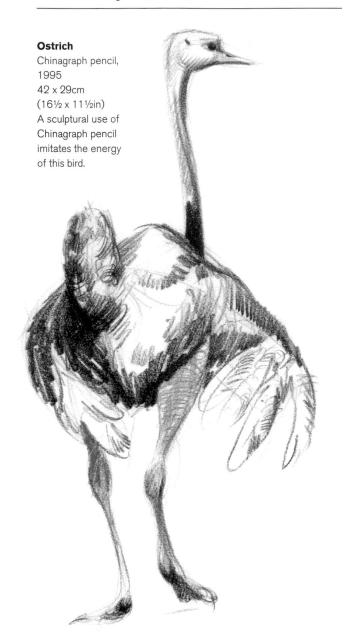

Tools of the trade: chinagraph pencil

The subtleties of a chinagraph pencil can be seen in these note-taking sketches, contrasting with a sustained study of sculptural light and form as in my sketch of the Brooding Mountain on page 75. I find it a wonderful medium to use when I am drawing animals or human figures as it responds so well to the various textures of feathers, fur and clothing. Because it is a very soft, waxy pencil it demands gentle handling with the initial stages of a drawing, after which it is ready to deliver strong dark mark-making when needed.

When you get additional time to draw, it's exciting to discover the special qualities of this pencil coming to life when used on textured paper. I enjoyed sculpting my drawing of the mountains overlooking Lake Annecy, France, where my pencil recorded a structured journey across the folds of the mountain crags and forests under the ever-changing storm clouds overhead.

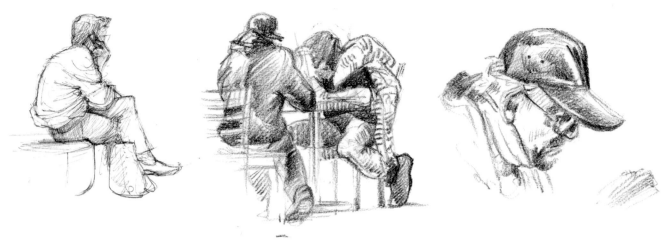

Catching Life
Chinagraph pencil, 2007
29 x 42cm (16½ x 11½in)
Complementary light and
dark Chinagraph marks are
an ideal medium for making
rapid figure sketches.

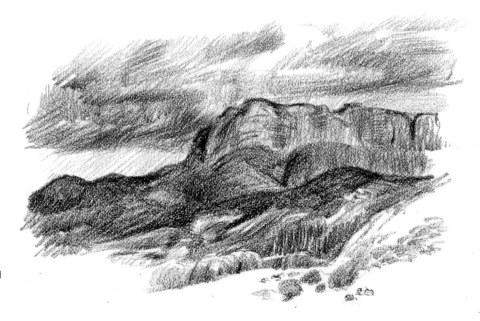

**Brooding Mountains
Around Annecy, France**
Chinagraph pencil, 2008
21 x 29cm (8¼ x 11½in)
Chinagraph pencil supplies solid
tones to convey the changing
mood of the weather.

Tools of the trade: chinagraph pencil and brush pen

Attempting to record every detail of the Budapest Opera House, my student was frustrated by the sheer number of windows. I stood beside him and made this rapid sketch to demonstrate that the ambience was as dramatic as any grand opera. Without the distraction of the windows, he recognized everything of importance. After putting some time between making a rapid sketch and revisiting it, you won't recall the exact details, but gesture, energy and ambience will remain.

The Opera House, Budapest
Chinagraph pencil and brush pen, 2001
25 x 50cm (10 x 19¾in)
The darker trees and street lamps complement the opulent edifice of the old opera house, reminiscent of an earlier century.

Opera House, Budapest

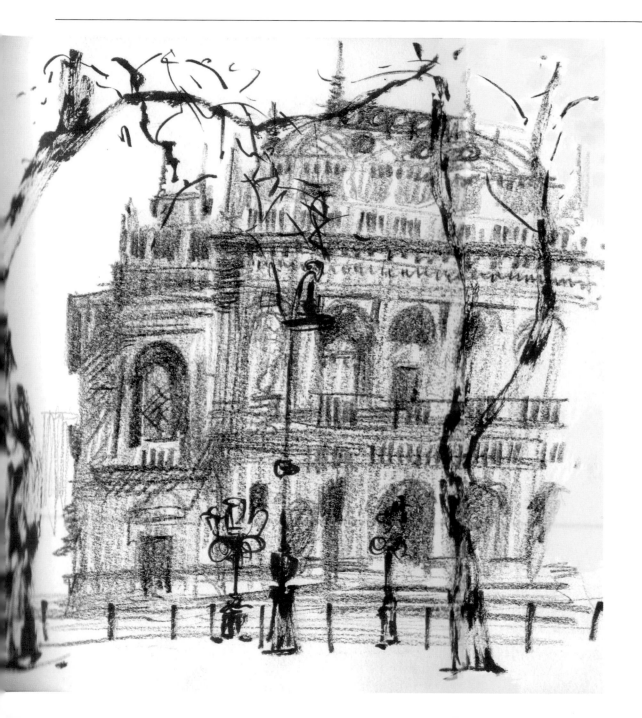

Tools of the trade: graphite sticks and putty rubber

An eraser is usually associated with the need to remove errors. However, it can be very rewarding to take the opposite path and try drawing with an eraser instead.

The monumental smooth hull of USS *Hornet* encouraged an energetic approach to drawing its massive structure. I rubbed my fingers into the graphite to define broad areas before using a putty rubber to sharpen edges.

USS *Hornet*, San Francisco
2B pencil 2008 29 x 42cm
(11½ x 16½in)
This sketch offers atmospheric perspective and spiky detail.

I applied a different approach to my cliff-top trees, building them up using graphite and then sculpting them with a putty rubber. Then I applied another layer and worked it with the putty rubber, a sequence that was repeated and refined until the result felt right. Everything can be destroyed or retrieved throughout this drawing process.

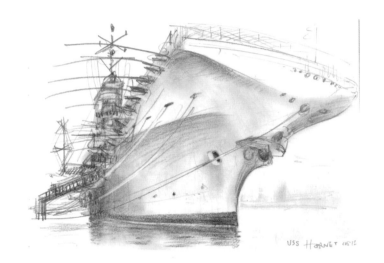

Weather-worn Cliff-top Trees
2B graphite stick, 2009
21 x 29cm (8¼ x 11½in)
Finely overlaid graphite sculpted with a putty rubber makes up these tree forms.

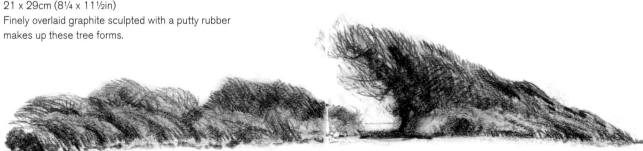

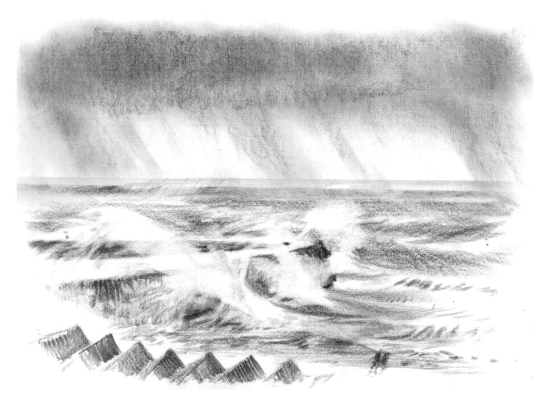

Storm Force at Lyme Cobb
2B pencil, 2006
21 x 29cm
(8¼ x 11½in)
Soft pencil, smudging and a putty rubber combine to capture rain and gale force waves pounding the harbour wall.

On a weekend visit to Lyme Regis on the south coast of England, I found a storm raking across the harbour with all its force. However, the sea spray, high waves and rain-torn clouds gave me, my graphite sticks and my putty rubber a perfect opportunity for a dramatic sketch.

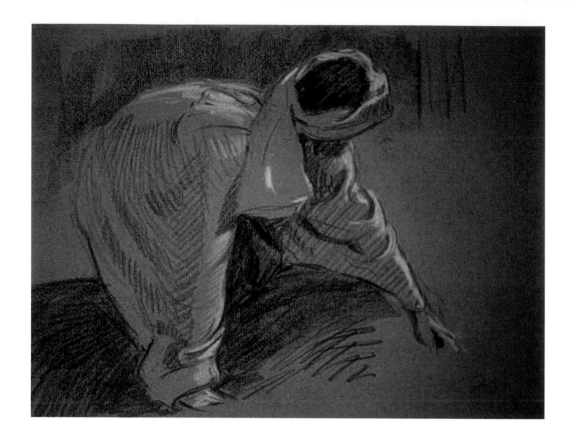

Tools of the trade: conté chalks and tinted paper

Conté chalks are a drawing medium made of compressed powdered graphite mixed with a base of wax or clay. Their beauty is best experienced when they are applied to tinted and textured paper, which provides a rich middle tone; the black drawing gains gravitas when white chalk is used to lift the highlights from the mid-tones. These studies may be used to establish the structure and tonal range from dark to light in preparation for making oil paintings. However, I also enjoy working with conté chalk not just as an underdrawing but as a drawing medium out of choice on lightly sized canvas.

Costume Study
Conté chalks, 1977
42 x 59cm (16½ x 23¼in)
The folds of the drapery and hatched lines spell out the anatomy of the figure.

Portrait Study
Conté chalks, 1987
59 x 42cm (23¼ x 16½in)
This black and white chalk
drawing emerges subtly from
the tinted paper.

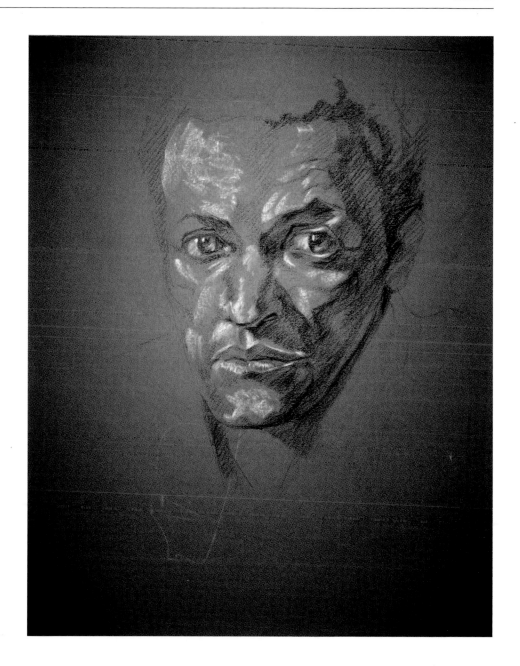

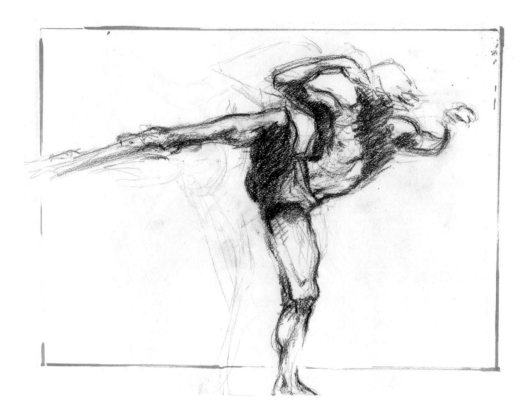

Here the energy of the dancer contrasts with the repose of the sleeping tiger opposite. There is a powerful and direct application of black chalk on white paper, with sculptural strokes adding life and structure to the anatomy to each of the drawings. My correction marks are purposely left visible and reinforce an energetic living history of both subjects.

My drawing of the dancer is one of a series of sketchbook studies made to catch the rhythm and energy of the human figure. I drew the tiger on a visit to Marwell Zoo – it's not easy to capture a tiger's agile and powerful walk as he continually paces a well-worn path round his enclosure.

The Dancer
Conté chalks, 2009
29 x 42cm (11½ x 16½in)
The action of drawing the dancer is equal to the dancer's action as he performs.

Sleeping Tiger
Conté chalks, 2000
42 x 29cm (16½ x 11½in)
The sense of weight and
anatomy here is created by
applying efforts to mark-making.

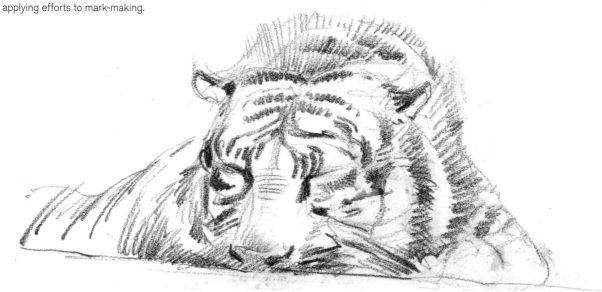

After his heavy lunch the tiger slept, giving me a rare
opportunity to study his supple body and solid head
with appropriately measured chalk marks.

Quiet Sunlit Driveway
Charcoal, 2008
29 x 21cm (11½ x 8¼in)
Charcoal offers an extensive
range of tone and opportunities
for varying textures.

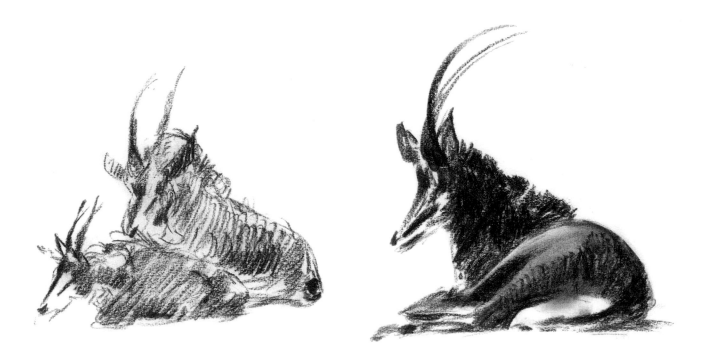

Tools of the trade: charcoal

Charcoal is made from willow sticks that have been burned to the desired consistency. It can be used with either a very light touch or heavier pressure to create intensely dark, sensuous rhythmic lines. Combined with a putty rubber, it makes the ideal medium for studies of dappled sunlight, shade and a rich array of leafy foliage. There are a great many textural choices to be had from an inventive handing of charcoal, through a subtle range of greys to solid black. I have also found it to be an excellent medium for rapidly sketching such subjects as animals that are rarely immobile.

Sable Antelope
Charcoal, 2010
42 x 59cm (16½ x 23¼in)
The soft textures of charcoal enable it to suggest mood and atmosphere.

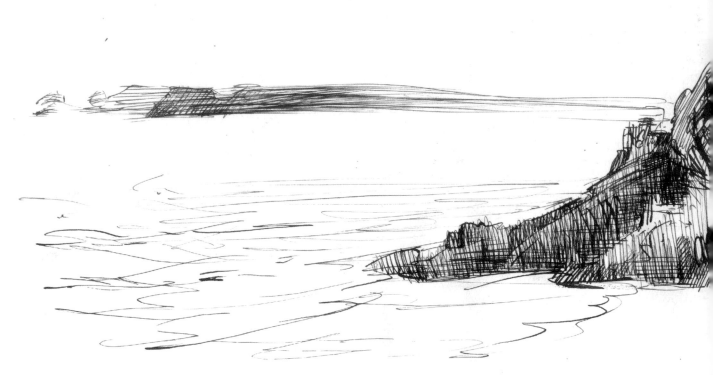

Tools of the trade: steel dip pens, flexible or firm

The flexible steel pen nib has the ability to vary between fine, delicate strokes and broad emphatic lines. The steel pen nib, on the other hand, is firm, but with sensitive handling it can produce a wide variety of meaningful marks to define light, shade and structure. In this sketch, the sea, the misty distance and the rocky coastline at Tenby show off the variety of lines that can be achieved with an 'old school' steel dip pen.

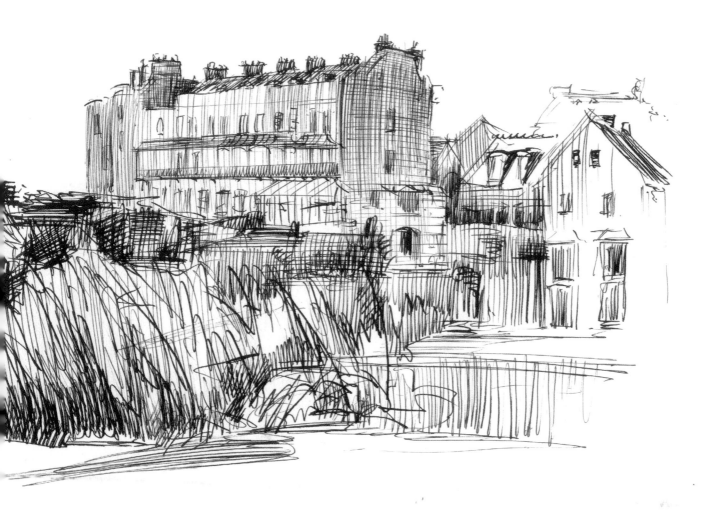

Tenby, South Wales
Firm pen and ink, 1997
21 x 58cm (8¼ x 22¾in)
The paper acts as white highlights, and the closer together the
ink lines are drawn the nearer the tone is to black. Don't scribble,
but sculpt each surface of the drawing with considered directional
vertical, horizontal and rugged lines.

Tools of the trade: brush pens

A direct application of the cartridge brush pen is ideal for capturing the essence of movement at rail stations, markets and any other location where plenty of people are hurrying about. It has a natural, fluid and lively line with which, using sensitive pressure, you can interpret whatever you choose, giving it energy and volume.

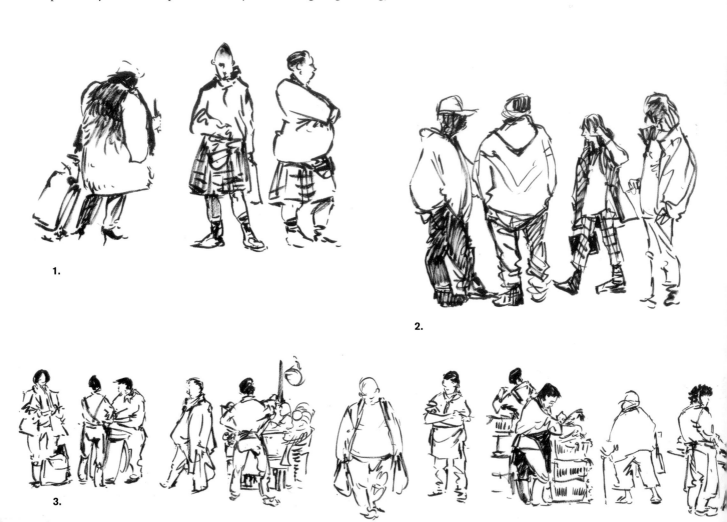

1.

2.

3.

1. Stansted Airport
Brush pen, 2003
21 x 29cm (8¼ x 11½in)

2. Meeting at Breda Station
Brush pen, 2001
21 x 29cm (8¼ x 11½in)

**3. Wan Chi Market,
Hong Kong**
Brush pen, 2003
21 x 29cm (8¼ x 11½in)

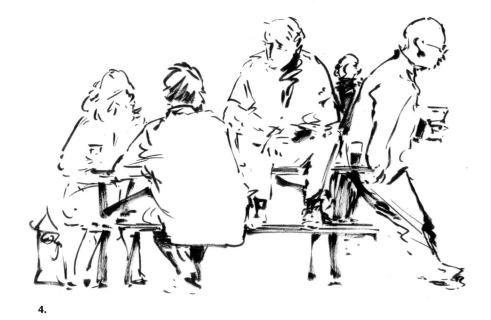

4.

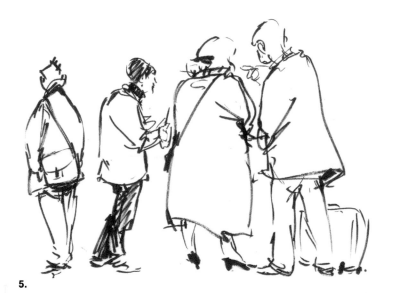

4. Bristol Watershed
Brush pen, 2001
21 x 29cm (8¼ x 11½in)

5. Lost on Breda Station
Brush pen, 2001
21 x 29cm (8¼ x 11½in)

Much of this type of drawing
relies on a lively interaction
between you and what you
see. Your observation and your
memory will create a lasting, but
living drawing.

5.

The Forbidden City
Brush pen, 2008
29 x 21cm (11½ x 8¼in)
Here spiky detail is offset by
areas of white paper.

Temple of Heaven
Brush pen, 2008
29 x 42cm (11½ x 16½in)
The Temple of Heaven is
concealed, peeping out from
inside a high gated wall.

The brush pen is at home in China, where the cities offer the artist inspiration to make a wide variety of compelling marks.

I always find the Forbidden City and Temple of Heaven impressive; there are so many opportunities to draw people who give scale and life to the massive architectural structures. Wherever I look I find extraordinary shapes and textures to describe.

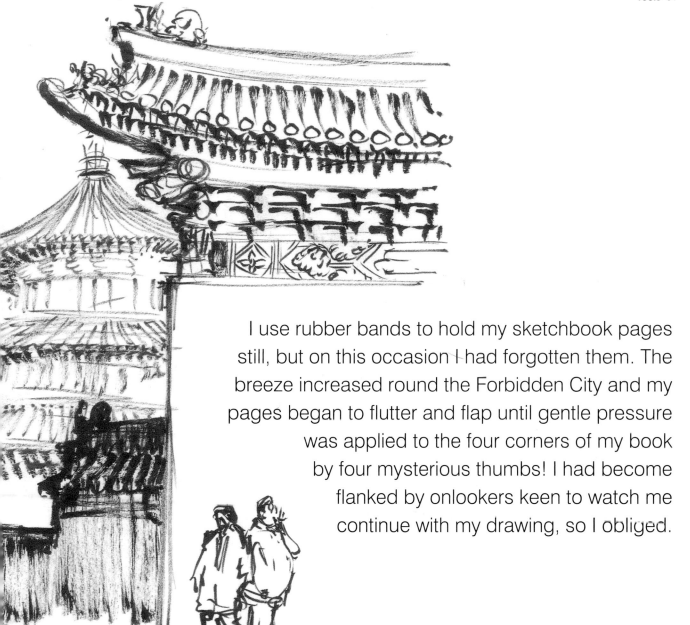

I use rubber bands to hold my sketchbook pages still, but on this occasion I had forgotten them. The breeze increased round the Forbidden City and my pages began to flutter and flap until gentle pressure was applied to the four corners of my book by four mysterious thumbs! I had become flanked by onlookers keen to watch me continue with my drawing, so I obliged.

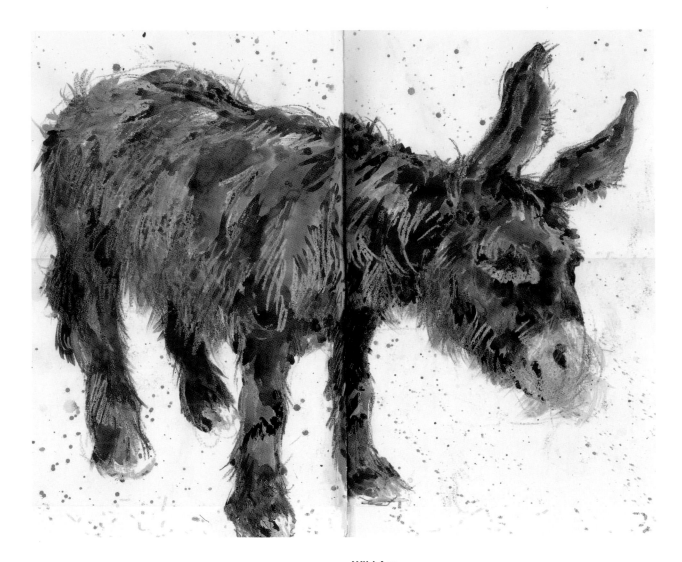

Wild Ass
Oil pastels,1995
42 x 58cm (16½ x 22¾in)
This shaggy beast has been carefully drawn with lines of waxy oil
pastel to model his anatomy.

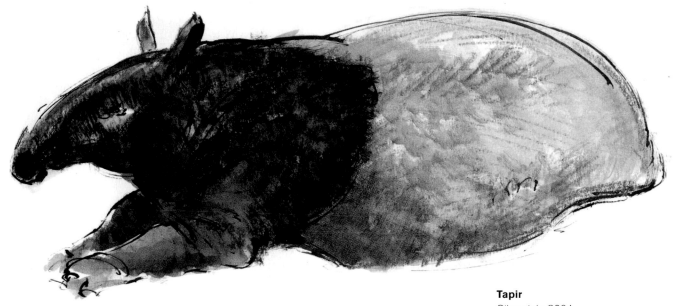

Tapir
Oil pastels, 2004
29 x 42cm (11½ x 16½in)
Structured mark-making
establishes meaningful form
that conveys the physicality
of the subject.

Tools of the trade: oil pastels

When you open a box of oil pastels they can look garish, and if bright and vibrant colours are what you are looking for, they will certainly oblige. However, my drawings here show another side to what they can offer.

These drawings demonstrate the need for sensitive observation to creat a variety of textures. Be inventive with your mark-making. A combination of oil pastels acting as a wax resist with washs of watercolours produces varied effects in modelling. I applied washes of colour overlaid with water soluble pastels to emulate the tapir's dense fur coat.

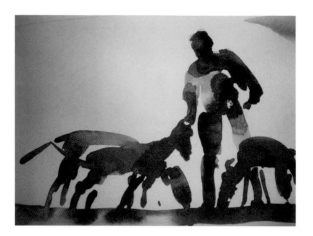

Actaeon and Diana
Watercolour, 2002
9 x 16cm (3½ x 6¼in)
Drawing wet-on-wet produces
imprecise, fluid effects.

Tools of the trade: watercolours

Using wet-on-wet watercolour can create some beautiful runaway surprises. My watercolour brush drawing of Actaeon and his hunting dogs shows how colours can be added and allowed to flood and spread. Although this technique offers freedom, you still have to apply caution to when and where to place your colour.

My sketch at Collioure was free from any form of detailed drawing – colour was the point of this work, so I allowed myself the luxury of planting colours in separate patches to offset each other. Finally I applied a wash of blue over the dry colour for the deep shadows.

Harbour Mouth, Collioure
Watercolour, 2001
21 x 29cm (8¼ x 11½in)
Freely applied colours are
held together here by a dark
wash overlay.

Painting this wisteria required great control, so I mapped out a loose sketch with a brush to guide my areas of colour.

Given the chance, watercolours have a life of their own as they move and evolve and you will soon begin to anticipate creating happy accidents with colour. I have learned to appreciate the uncontrollable nature of this poetic and free-spirited medium by developing my own method of application. I approach it with respect, but I remain in charge by using Laban's efforts combined with timing and flow.

Wisteria
Watercolour, 2007
29 x 21cm (11½ x 8¼in)
Here I used a combination of brush drawing and free colour.

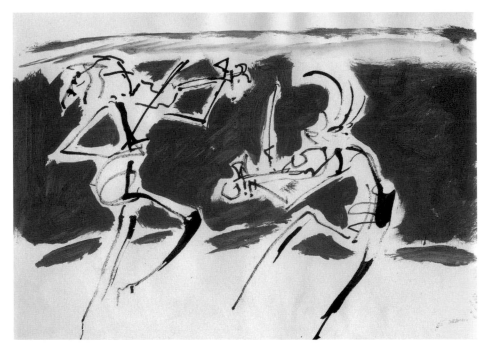

Fiddle Players
Twig and inks, 1995
19 x 25cm (7½ x 10in)
The figures are made visible
by the intenseley colourful
background shapes.

Tools of the trade: quills, sticks, Indian ink and watercolour

Indian inks allow applications with pens, sticks or quills and are waterproof, thus remaining stable under of washes of tone or colour. The sketches look free but they are controlled through Laban's notation of efforts in preparation for my outer expressive mark-making.

I enjoy the wilful nature of quills and sticks as they splutter, spit and then suddenly dry up, producing characteristically expressive marks. I get to know how the instrument works and then plan my mark-making to suit my intention, taking care not to cramp the spirit of the tool. I lead it to believe that it is still as independent as ever – a deception that adds a little more fun to the act of drawing.

Peacock
Quill pen and watercolour
Oct 2011 21 x 29cm (8¼ x
11½in)
Freely applied wet on wet
watercolour. A simple design in
line and colour.

It was a treat to set off from art school for my first plein-air sketching holiday, drawing kit packed. On a rocky foreshore, by some fishing boats, I settled down in a perfect spot. Then, after choosing my subject, getting out my paper and ink and taking a deep breath, I realized I had forgotten my pen. I looked at the ground in despair. There at my feet lay a driftwood twig! So I was introduced to sketching with twigs and I can remember my elation at being pushed out of my comfort zone, albeit by accident.

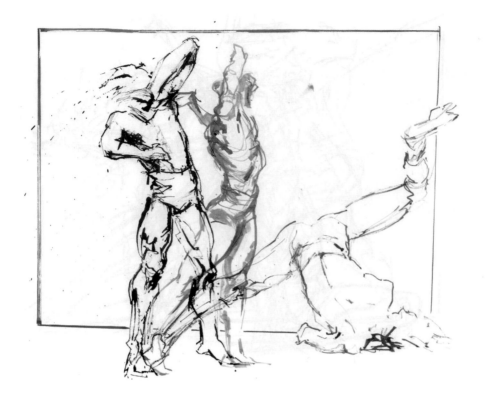

Dance Strobe
Quill pen and inks, 2009
21 x 29cm (8¼ x 11½in)
The fickle inky line delivered
by quills or sticks suit the
energy of the dancer as he
realizes his space with timing
and movement.

For an enjoyable combination of the unpredictable and the controlled, the free and accidental marks made by the quill pen or sticks add a wonderful energy to a sketch. The boxer's face opposite reveals a tense, guarded body language, interpreted by a sculptural use of my spattering quill pen. When you use this type of pen, or any other drawing instrument for that matter, you will be aware of controlling your mark-making with timing that keeps you constantly aware of the three-dimensional nature of your subject. The movements of the dancer could easily be a physical representation of your inner preparation to draw the boxer.

Boxer

Quill pen and ink, 2008
29 x 21cm (11½ x 8¼in)
Every stroke and line has an
important role to play in defining
structure and form.

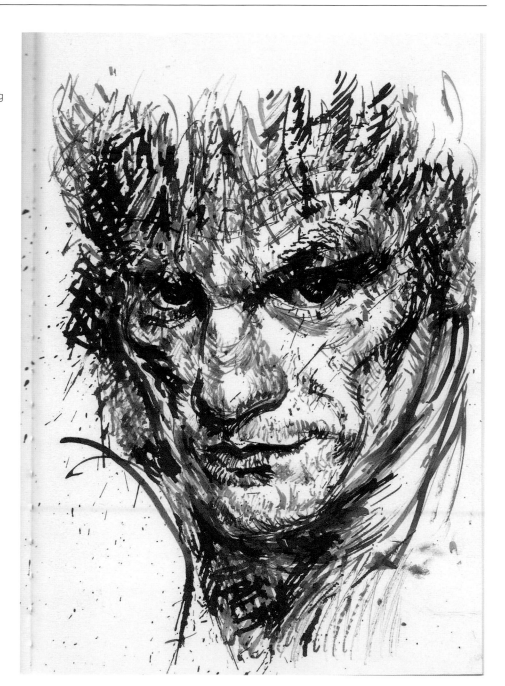

Cottage, Portland Bill, Dorset
Watercolours and oil pastels, 1995
42 x 59cm (16½ x 23¼in)

Lighthouse, Portland Bill, Dorset
Watercolours and oil pastels, 1995
42 x 59cm (16½ x 23¼in)

Davit Crane, Portland
Brush pen and coloured pencil, 2007
42 x 29cm (16½ x 11½in)

Pulpit Rock, Portland
Brush pen and watercolour, 1995
35 x 59cm (13¾ x 23¼in)

1.

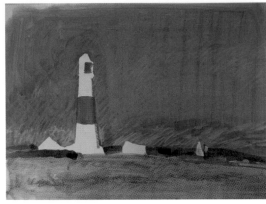

2.

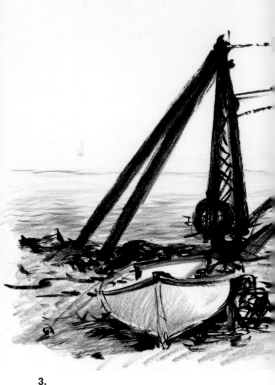

3.

Tools of the trade: mixed media

Combining different tools in one drawing allows an artist to find many new effects, so be prepared to experiment. Portland Bill is a narrow promontory jutting out from the southernmost tip of the Isle of Portland on the south coast of England. No matter what the weather may be, the surprise of the light, the land and the sea is always renewing. Working on tinted paper, I used watercolours with oil pastels to create a spirited combination for my drawings of the lighthouse and cottage.

It is advantageous to take a wide selection of mixed media with you. By anticipating your location you will not be disappointed or restricted. It's always a great thrill to find yourself well prepared to draw anything.

4.

It is useful to compare drawings made with different tools to guide your choices for future subjects. I used a brush pen and coloured pencils to give texture and define the rusting davit crane and the fibre-glass boat. For my drawing of Pulpit Rock, just around the corner on this headland, I chose waterproof Indian ink applied with a stick, then watercolour to give a much looser effect. The blotchy effects of the wild weather are visible in the centre fold of my sketch.

Barton sleeping
iPad, 2012
A minimal line tool
catches the cat's
relaxed pose.

Tools of the trade: the iPad

The iPad is a welcome addition to the toolbox, offering a versatile array of drawing options. This instrument is not a replacement for pencil, brushes and paper, but is an alternative choice and, for some, an easier and quicker way to work outdoors.

The iPad toolbox menu offers familiar names such as pencils and brushes, but it must be remembered that the iPad, or any other digital application for that matter, is not a conventional drawing tool. Using my finger to draw helped me to loosen up, making me less precious about my mark-making. There is something primal about drawing with one's finger, but if you prefer, a stylus offers a familiar implement to hold. Be patient with this new tool. The cat and the lamp-stand were my first sketches but as I gained confidence, I developed more painterly styles.

Reading Lamp
iPad, 2012
This sketch resulted from free-flow mark-making.

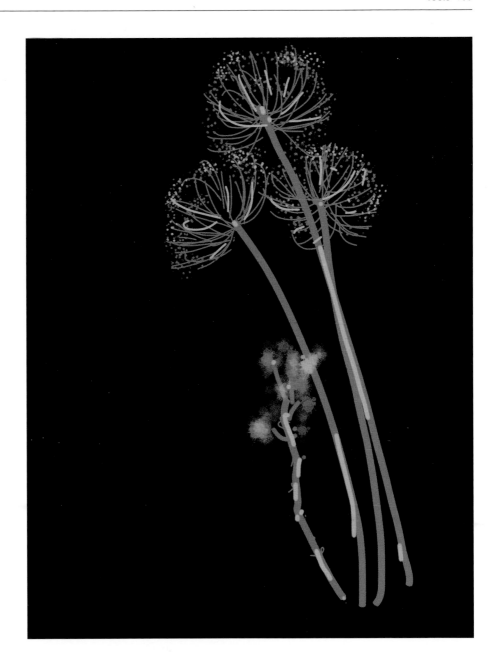

Dried Allium Stems
iPad, 2012
Close observation and
controlled mark-making
guided this sketch of attractive
dried seedheads.

It was exhilarating taking a direct approach to making these quick sketches from life on the street by grabbing first impressions, the eye and the finger working together to catching the feeling of a location. The fluent accidental off-register strokes of colour and line add a new excitement.

6th and Prince Street, NYC
2012, iPad
Finger-painting added to the sponaneity of this sketch.

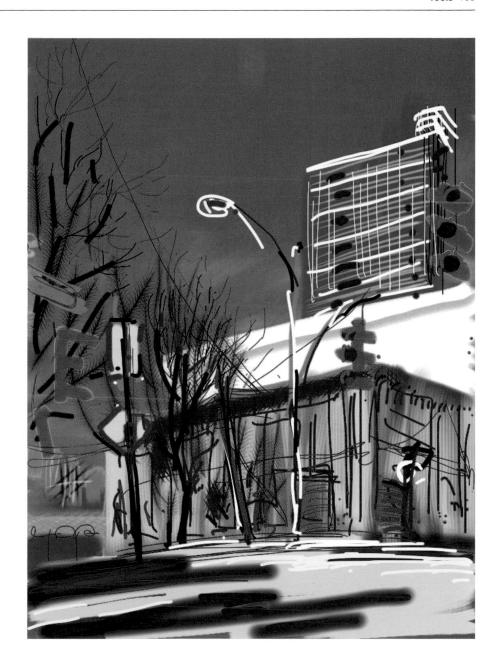

Kent and Metropolitan, Williamsburg
iPad, 2012
This loose finger drawing has the vibrancy that comes from a complementary colour palette.

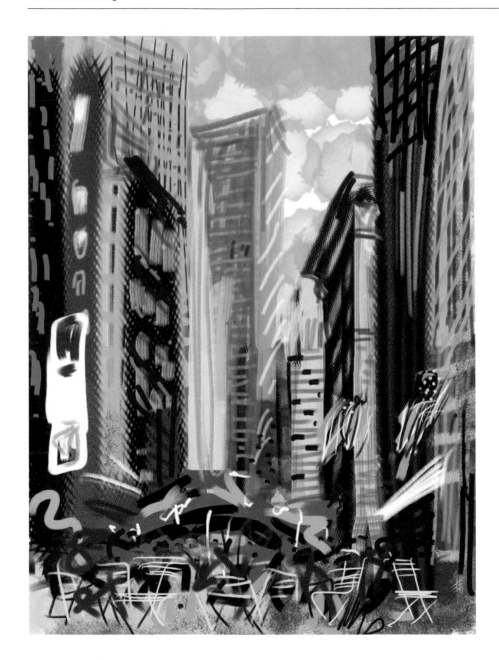

Herald Square, Manhattan
iPad, 2012
Here I used digital texture to
describe my observations.

**Cherry Blossom in Chelsea,
Manhattan**
iPad 2012
Layered digital colour textures
combine with the observed light.

It is really hard for me to leave my sketchbook at home, as it has become second
nature to me to carry it everywhere I go. However, on this occasion I made a conscious
effort to go out with no alternative but to work on my iPad – an experience worth
remembering. My direct, painterly application of finger-work, combined with a vibrant
colour palette, catches the vitality of Manhattan in springtime.

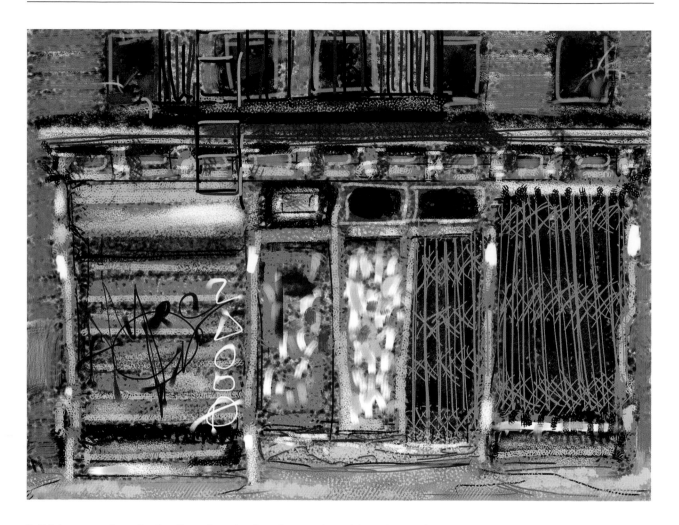

I didn't want to lose the detail on the printshop I spotted on this outing, so because my ability to use my iPad was limited, I resorted to my familiar brush pen and sketchbook.

East 4th Street Printshop:
Brush pen, 2012
29cm x 42cm (11½ x 16½in)
Closely observed information is freely drawn with a brush pen.

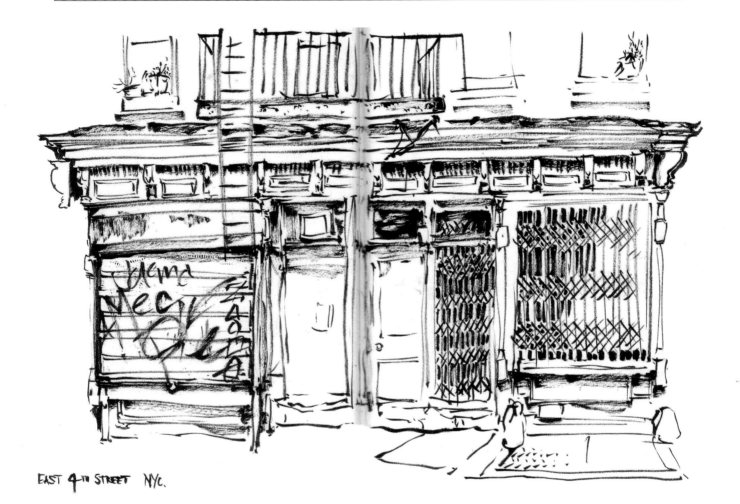

EAST 4TH STREET NYC.

To get a feeling for this shopfront in a limited time, I felt more at ease making a quick on-the-spot study with my brush pen in my sketchbook. Later, with more time to experiment, I went ahead with my iPad and finger to redraw the image and chose the appropriate colours and textures to bring out the best of the old façade.

East 4th Street Printshop, NYC
iPad, 2012
Here digitally drawn and textured finger painting is derived from sketchbook notes.

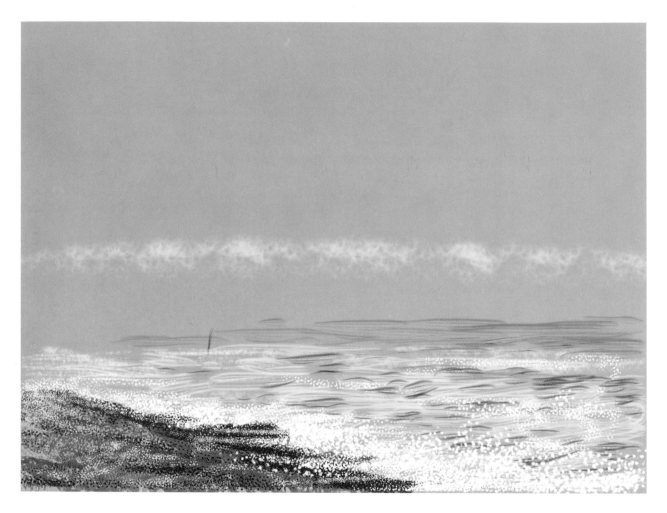

Sea Mist
iPad, 2012
Aiming for an atmospheric, misty finger painting.

When I returned home to the UK from New York, I couldn't wait to get out on location with my new digital sketching companion. The first thing I noticed was not only the very different landscape, but the difference in the light and the colour, so my senses were challenged once more. I had to rethink my colour palette and my approach to my drawing. I had become used to my selection of tools for urban scenes so it was refreshing to try something new.

Evening Light
iPad, 2012
An exercise in optical
colour mixing.

Buck
2B Pencil, 2004
42 x 29cm (16½ x 11½)

MARK-MAKING

Breathing sensuality and life

This chapter discovers how the use of different drawing tools can add conviction to the character of the things you draw. It examines line, volume, tone, texture, structure and weight – the attributes that unite to make a drawing.

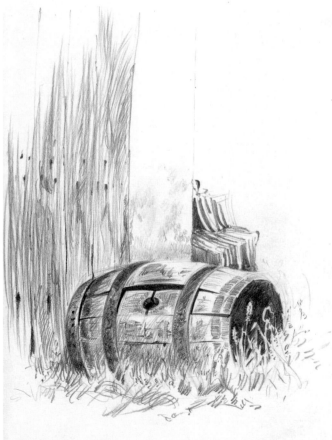

Subjects need not be immense panoramas to excite the eye. I was caught by the history and personality shown on this old silvery wooden gatepost. It has stood for many years, despite being weathered by the seasons, wrapped in wire and pierced with iron fixtures; it continues to do its work at the entrance of its Perthshire field.

Making studies of small, seemingly insignificant subjects such as this gatepost can offer exciting opportunities for you to put your drawing efforts into practice. Your approach to drawing the subject is paramount. It demands close scrutiny and a subtle use of your drawing instrument. Every crack and split and splinter radiates its own personality, every weather-pitted atom demands recognition and a sense of phrasing in the way you modulate the pressure of your drawing tool.

Wooden Wine Barrel, Les Salles de Castillon
2B Pencil, 1986
21 x 29 cm (8¼ x 11½)

**The Old Gate Post,
Scotland**
2B pencil, 2007
29 x 21cm (11½ x 8¼in)
Here I applied Laban's efforts to
control line and texture.

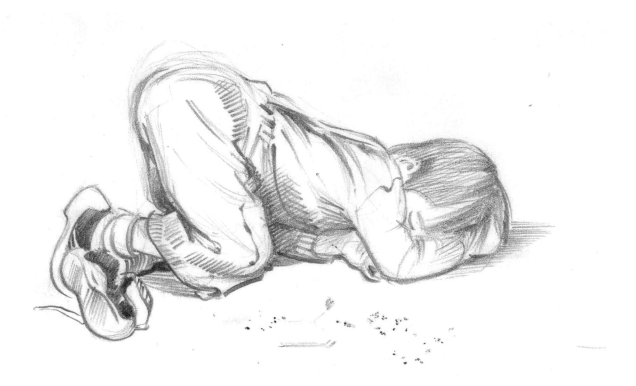

Byron Napping
2B pencil, 1982
29 x 21cm (11½ x 8¼in)
A modulating line caresses the form of the sleeping boy.

Line and volume

Line is the most commonly used, but perhaps most misunderstood, form of interpreting a subject. It is without doubt the most versatile of drawing methods, offering a variety of linear tones and textures that have the power to excite. Volume can be created simply by the varied strength and sensitivity of lines, and with practice you will develop a meaningful fluid line technique to convincingly express the volume of your subjects.

When I observe my subject I use my eyes like hands moulding a clay pot and my emotional antennae to sense the object. My pencil lines realize the form by leaving a history of their rounded journey like that of a snail trail, each line mapping every surface, leaving you in no doubt that they are three-dimensional.

If you are using a pencil, begin with gentle marks to catch the general shapes as you assess the subject. Work over your preliminary lines with a new, slightly stronger layer of corrective lines: successive marks will benefit you as you refer to your previous underdrawing as you refine your drawing. Resist the urge to erase, as the underdrawing will provide a valuable and living story to your finished work. A brush pen, however, calls for greater care as your marks cannot be erased. Use the tip of your brush to gently plan the proportions of your sketch and a full brush to apply the darker detail.

Rainy Day, Portland
Brush pen, 1997
21 x 29cm (8¼ x 11½in)
The brush pen line is almost continuous as it weaves its way around the dripping figures.

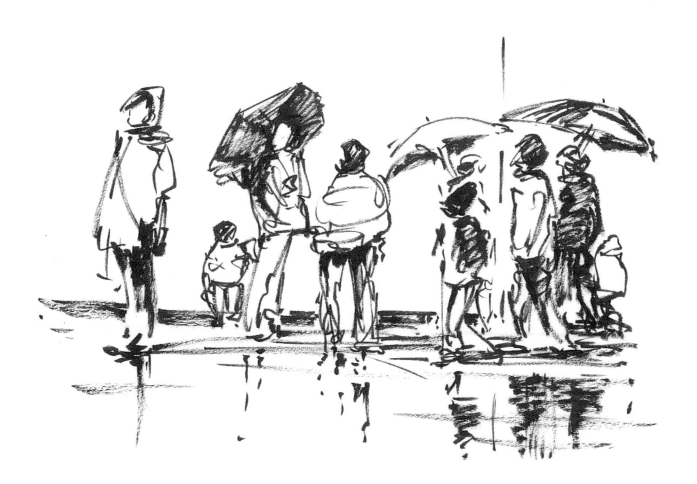

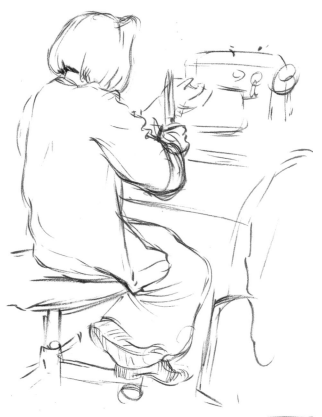

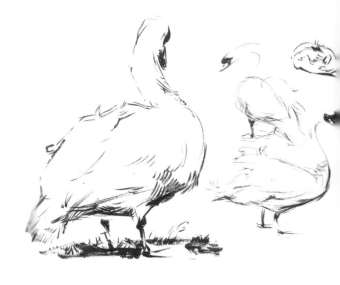

Astor Sewing
Brush pen, 2008
29 x 21cm (11½ x 8¼in)
A varied brush line
creates the form.

To appreciate how these simple studies were made, consider my application of Rudolf Laban's notation of space, weight and flow combined with time, or phrasing.

I allowed my mind's eye to assess and circumnavigate each shape, visualizing my drawing before I touched the paper. Every line has its purpose in describing form through layers of clothing or feathers, registering the hidden anatomy. There are no wasted lines: nothing erased. The eye and hand have worked in close partnership to understand the form and then relay their three-dimensional findings on to the two-dimensional page.

When you draw, try to become familiar with the practice of drawing as though you were about to conduct an orchestra; adjust your breathing to focus your mind on your subject, to sense its shape and form before you begin. Initially, it sounds an artificial thing to do, but remember it is an inner experience – a meditation.

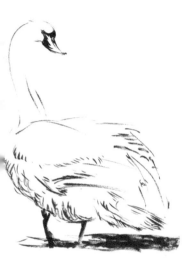

Swans
Brush pen, 2007
25 x 21cm (9¾ x 8¼in)
A varied brush line creates
form and feathers.

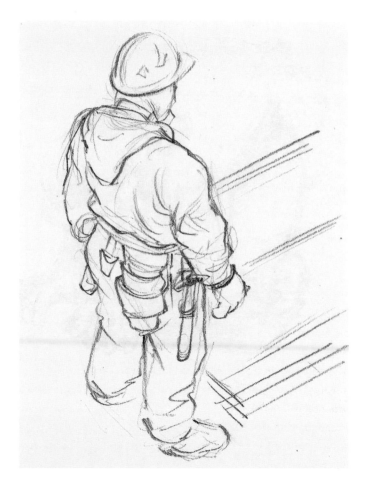

**Construction Worker,
New York**
4B pencil, 2006
29 x 21cm (11½ x 8¼in)
Amodulating pencil can
produce volume and weight.

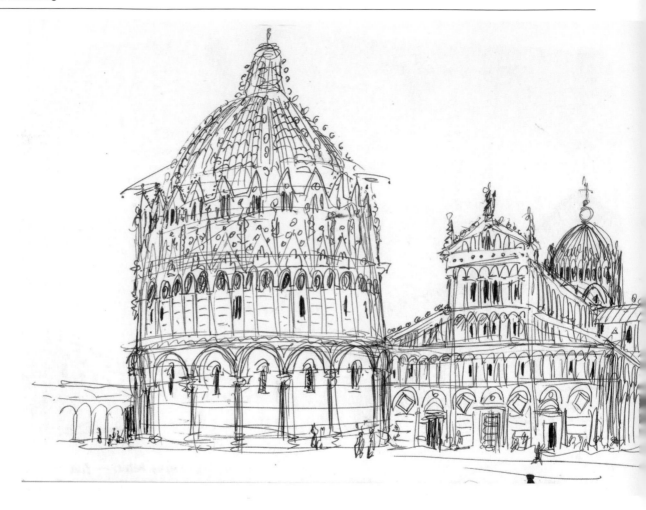

Fine-point and ballpoint pens are capable of a wide variety of expressive marks when handled with care. In Pisa, I dodged through a hot and crowded street market brimming with souvenirs and turned left through a large archway into the wide Piazza dei Miracoli (the Square of Miracles). A miracle in itself: nothing can quite prepare you for seeing the Leaning Tower of Pisa and the Piazza del Duomo for the first time.

**The Cathedral and the
Leaning Tower of Pisa, Italy**
Fine-point pen, 2001
21 x 58cm (8¼ x 22¾in)
Light and space are conveyed
by a free-flow pen line.

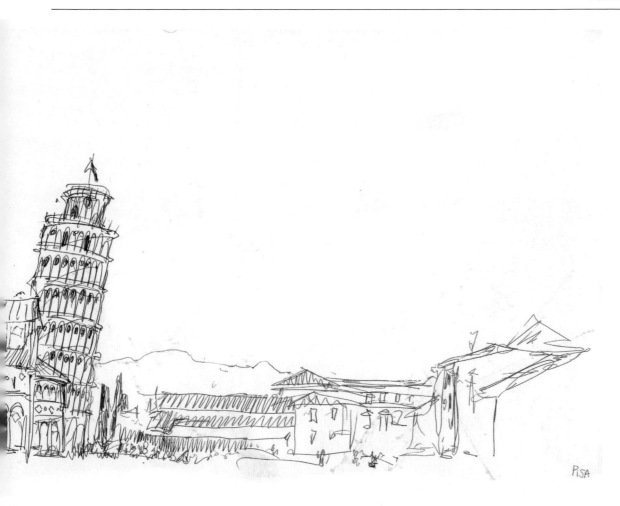

I wanted to record my immediate response to this white marble masterpiece, bathed in the bright Italian sunshine, as I first saw it. To catch the light and airy atmosphere a fine-point pen seemed most appropriate. It retained the whiteness of the architecture and at the same time gave a decorative linear texture to the whole.

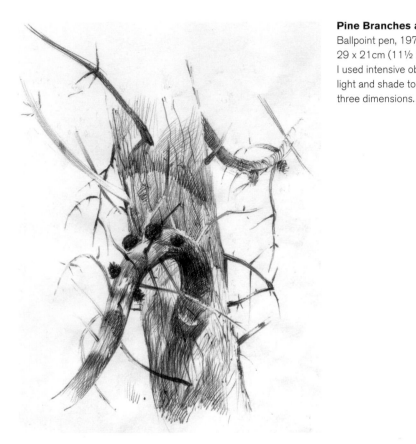

Pine Branches and Cones
Ballpoint pen, 1975
29 x 21cm (11½ x 8¼in)
I used intensive observation of
light and shade to interpret the
three dimensions.

Observing tone and texture widens your approach to drawing by triggering your sense of touch. Your inner attitude must prepare your awareness of space to deliver an outer action with timing, weight and flow to facilitate a tactile experience of mark-making.

If you like to draw with a ballpoint pen, give it some respect! They are not just for writing shopping lists; they love textured paper, a partnership that delivers a good range of tones from wispy pale greys to forceful darks. With sensitive handling they have a lot more to offer. Here my challenge was to make a close study of light, shade and texture, catching the spiky nature of this pine tree. A drawing made from this particular angle,

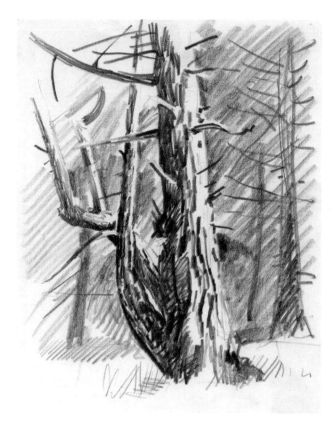

Giant Redwood
4B pencil, 1996
29 x 21cm (11½ x
8¼in)
Varying pressure on
the pencil makes this
study of tree bark
tactile and convincing.

with its branches projecting out in all directions, requires an intense study of the effects of light and shade.

The giant redwood tree, drawn with a 4B pencil, shares the same constant interchange between light areas and dark areas as they help each other to establish their positions in space: forwards or backwards. Although you are interpreting the subject's three dimensions in a study such as this, read the light and shade in simple patterns – shapes lying side by side.

When I apply texture to a drawing, my hand reacts by imagining it is touching the rough or smooth surfaces of my subject, thus making my drawing instrument deliver an appropriate mark.

Try to experience the material surfaces of your subject as you draw, since by doing so you will create a lasting memory of them as they were in reality. The textures of overgrown terracotta tiles, mature stone and distorted wooden wine barrels with rusting metal bands baking in the hot sun are one image etched on my mind, reinforced by the drawing shown below.

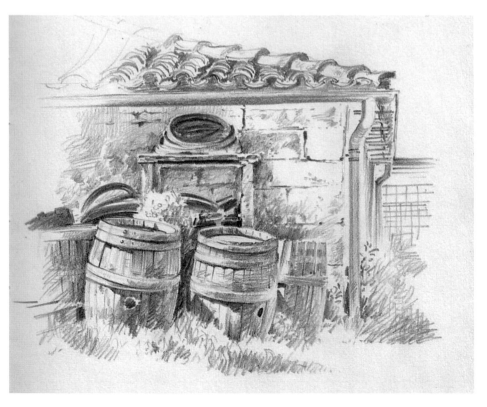

Around the Vineyard, Moulin Castilian la Bataille, France
2B pencil, 1986
29 x 21cm (11½ x 8¼in)
Here there is a mark for every textured surface.

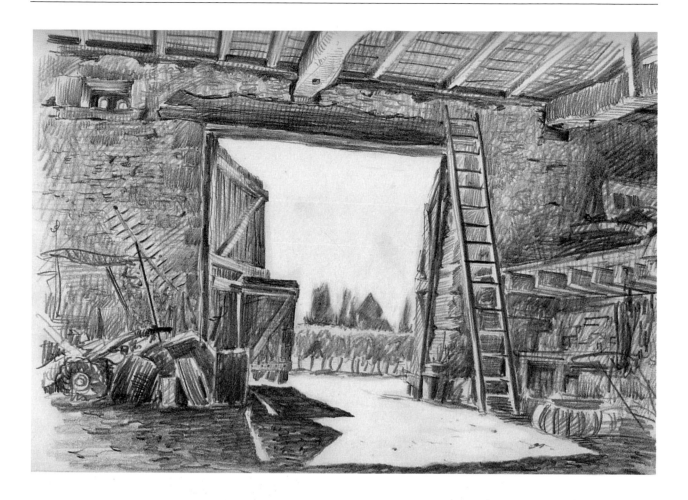

Spending time studying the special relationships between light, dark and reflective light will repay your patience in abundance. My study of a vineyard barn is a very revealing observation of the effects of intense sunlight, reflective shadows and extreme dark. Notice the subtlety of the changing tones, from highlights of white paper through mid-tones to pressure-driven pencil work.

Vineyard Barn, Moulin Castillon-la-Bataille, France
2B pencil, 1986
21 x 29cm (8¼ x 11½in)
Closely observed patterns of light and shade make for an atmospheric picture of a barn.

Try to relate your choice of drawing medium to your subject in order to bring out characteristic surface textures such as brocade, silk, cotton, linen or leather.

Studies in the Costume Museum, Bath
Coloured pencil, 1989
29 x 21cm (11½ x 8¼in)
In these studies, patterns and line textures imitate fabrics.

Costume Studies
Chinese ink wash, 2006
21 x 29cm (8¼ x 11½in)
29 x 21cm (11½ x 8¼in)
Broad blocks of light and
mid tones are detailed with
black wash.

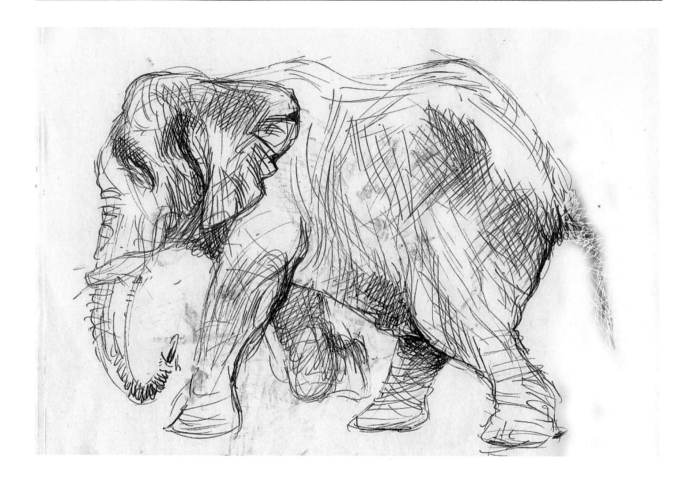

Structure and weight

Drawing the leathery lined skin of this elephant presented a wonderful chance for my mind's eye to sculpt its entire bulk before seeing the outcome emerge on my page. The lines I have used specifically record the elephant's skin and bones; they are directional, not random scribble.

Young Elephant
Fibre-tip pen, 1999
17 x 22cm (6¾ x 8½in)
Light and loose flowing pen lines combine to give weight to the elephant's shape.

In the case of the canvas tent, the luminosity of the light passing through the canvas was the attraction. Emphasizing the shadows in the foreground and background went a long way towards establishing the tent itself.

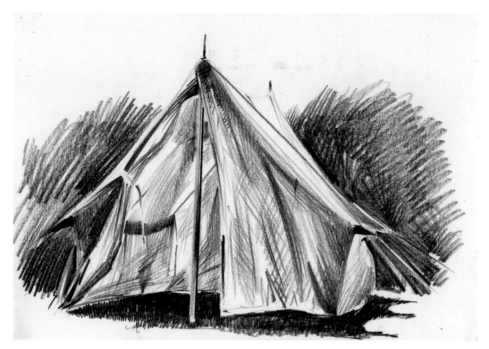

Sun-warmed Canvas
Coloured pencil, 1990
21 x 29cm (8¼ x 11½in)
Intense black creates light and lightweight structure by comparison.

Remember, the term 'weight' applies to both heavy and lightweight subjects.

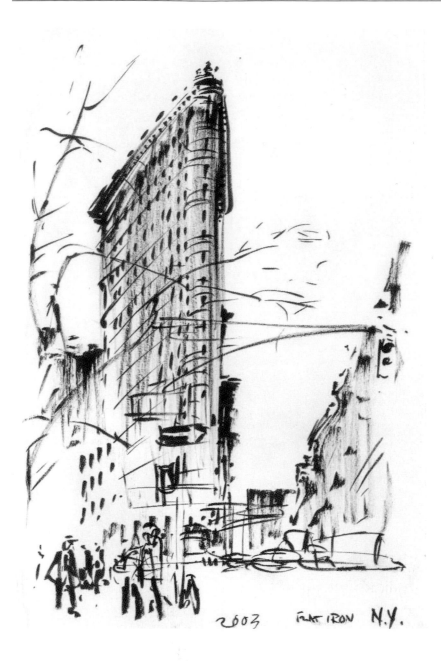

2003 FLATIRON N.Y.

Halted by traffic lights, I had a great view of New York's Flatiron building. I began to sketch at speed with immediate vertical brush strokes. I blocked in the striking perspective with lines, dots, dashes, a scribble of people and a tree. Done!

The Flatiron Building, New York
Brush pen, 2002
29 x 21cm (11½ x 8¼in)
This drawing has an almost equal arrangement of light and dark.

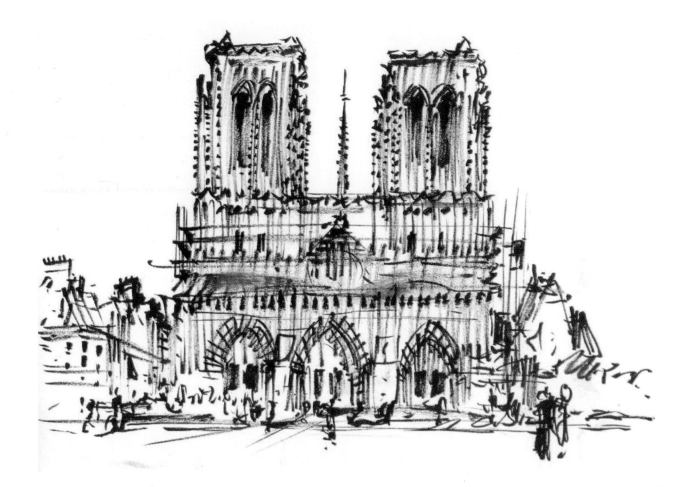

Using rapid sweeps of my brush, I established the dominant silhouette of the building. Then, with high-speed staccato flicks and dashes, an impression of Gothic detail emerged.

Notre-Dame Cathedral, Paris
Brush pen, 1996
21 x 29cm (8¼ x 11½in)
A pattern of vertical and horizontal lines is detailed with dots and dashes.

When time permits, you can have the pleasure of exploring the detail and texture of your subject. Vertical and horizontal pencil strokes define the structure of this gateway bathed in direct and bounced sunlight, creating deep and reflective shadows. I reserved the details for the main part of my subject, avoiding any desire to add detail to everything in sight. Equally this applies my study of the resting takin, opposite. The tone and detail are given to his head, which exerts enormous mythic presence and power.

**La Porte Brunet,
Saint-Emilion**
2B pencil, 1986
21 x 29cm (8¼ x 11½in)
Vertical and horizontal lines
combine to give strength.

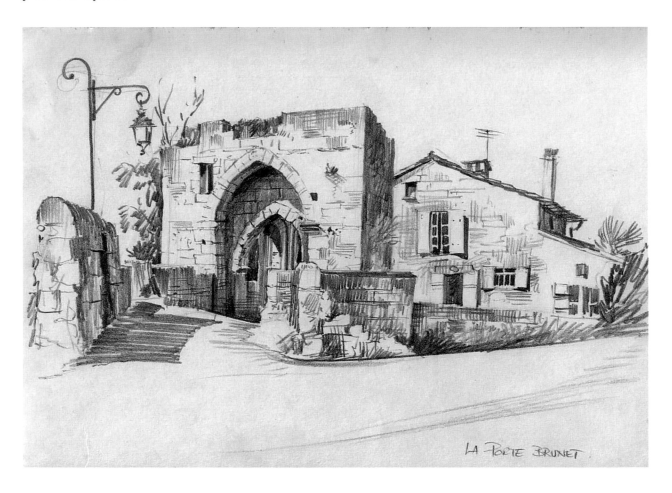

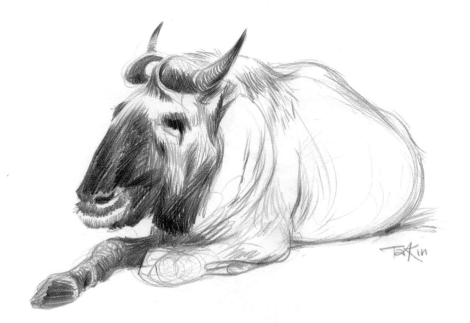

Takin Resting
2B pencil, 2010
42 x 29cm (16½ x 11½in)
This modulating line defines the
entire form, giving weight to
the back of the animal.

Lorimar St Station, NY
Brush pen and coloured pencil,
2009
21 x 29 cm (8¼ x 11½)

LIFE FORCES

The mountain imitates the dancer

This chapter considers the relationships between character, emotion and dramatic movement. Refreshing our approach to movement and rhythm can help us to reinvigorate our senses and imbue what we assume to be static with the spirit of the dance.

It would be a mistake to think of movement and rhythm as only referring to such activities as walking, running or dancing; they can equally apply to body language among groups of animals or people, drapery, and even solid structures such as architecture and landscapes. Movement and rhythm are embedded in the spirit of the world around us, calling out to be observed more closely and given respect.

Landscape drawings offer a wonderful opportunity to sense the rhythmic movement of the earth beneath our feet. Rocks are a time capsule asking to be recorded with sculptural strokes of the drawing tool, defining the form and recognizing their lifespan from their creation through their continuing evolution. On the Jurassic coast in Dorset, southern England, Stair Hole at Lulworth Cove is one such place where evidence of this movement surges up through the surface. Known as the 'Lulworth Crumple', Stair Hole is 30 million years old and commands our respect by virtue of both what we see and what we understand of the shockwave of energy that first formed it.

Stair Hole, Lulworth
Coloured pencil, 1988
29 x 42cm (11½ x 16½in)
Controlled observation from
the diaphragm to the hand
prepares the drawing implement
to experience the contours of
the subject.

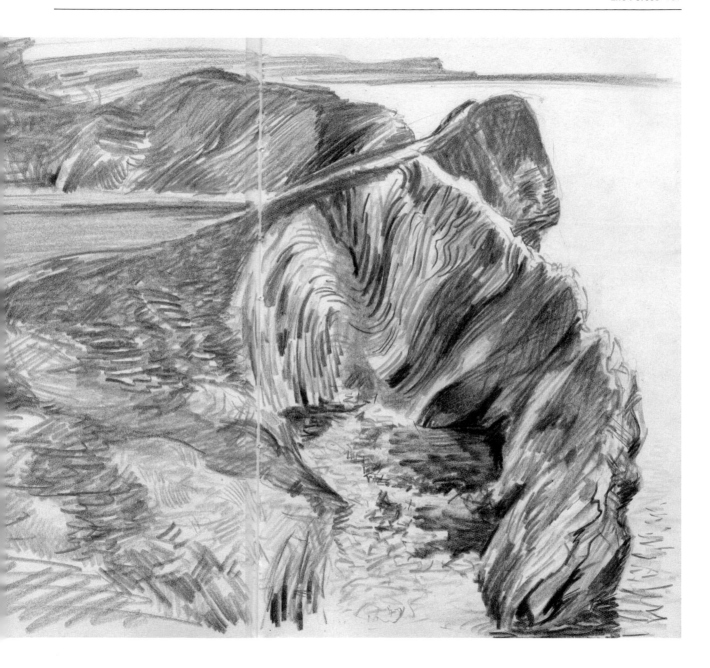

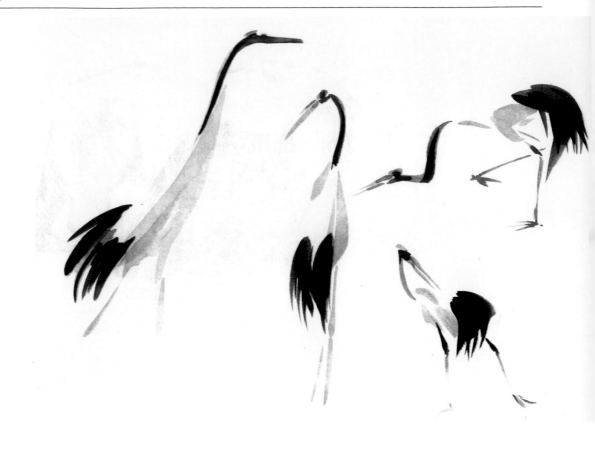

The Great Wall of China is a wonderful example of snaking energetic landscape combined with architecture. The way to draw a location such as this is to sense the energy and then draw what you feel.

I conveyed the rhythmic and graceful movement of the cranes by applying pale strokes of grey to establish the line of action through their bodies. The darker grey holds the shape of their expressions, while the black markings confirm their gestures.

Cranes
Watercolour, 1998
21 x 58cm (8¼ x 22¾in)
The fluidity of watercolour traces the elongated, graceful shapes of cranes.

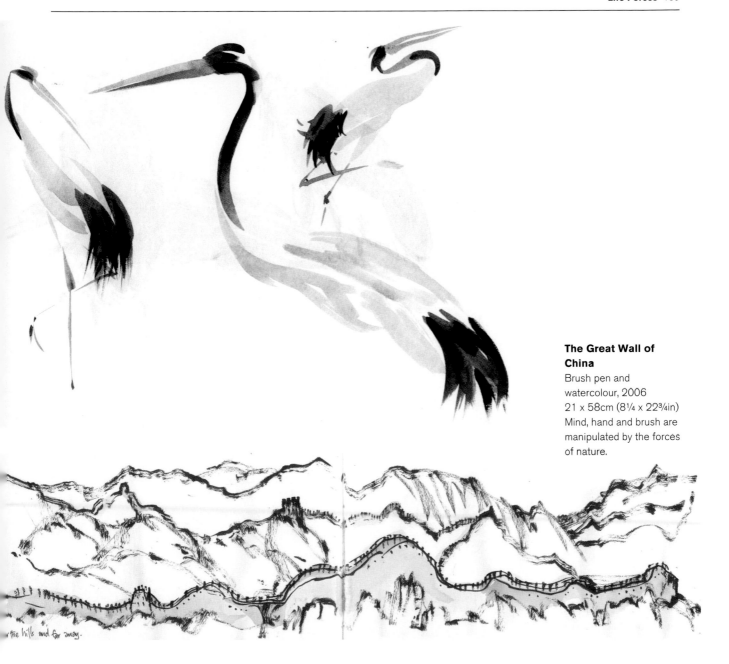

The Great Wall of China
Brush pen and watercolour, 2006
21 x 58cm (8¼ x 22¾in)
Mind, hand and brush are manipulated by the forces of nature.

the hills and far away.

Gesture and body language tell a story or intention by emphasizing rhythms that encapsulate the energy and feeling running through every subject: its line of life.

All the characters here were effectively drawn from life, though it is not always convenient to take out a sketchbook at the time. The cocktail party group was drawn from memory immediately after the event, but the drawings retain the essence of the party spirit and continue the narrative.

The personal body language of the group of people sharing each other's company around a table betrays their individual thoughts and intentions. Take a closer look; they are together in body, but not in mind.

At one time I would draw what I saw, simply from life or imagination, but then things changed. It was while I was working on an illustration assignment that I made a chance discovery concerning the relationship between my subconscious thought process before starting to draw, and my physical outer action once I drew.

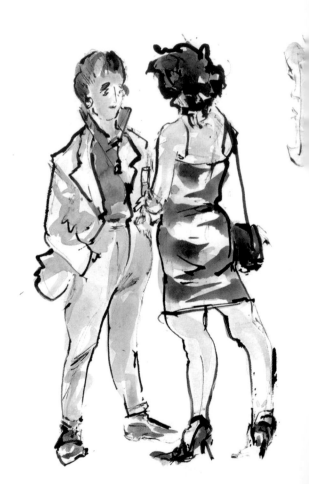

Cocktail Talk
Fine-point pen, 2004
29 x 60cm 11½ x 23½in)
On this occasion the pen is
fuelled by intrigue and jealousy.

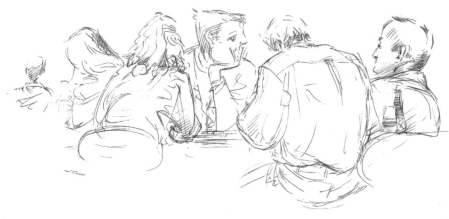

Table Talk
Quill and ink, 1998
21 x 29cm (8¼ x 11½in)
A look betrays a thought.

My challenge was to draw characters who would use forceful body language to communicate their attitudes: pessimistic, optimistic, lost or excited. Their body shape should highlight their frame of mind. As I stood at my desk, I became aware of unconsciously acting out the gestures and body language of my characters as I drew. Standing had freed me from the constraints of a seated position, allowing me to sway naturally back and forth. My entire body experienced my characters' inner attitude, which was transmitted to my drawing. The results were energetic and expressive.

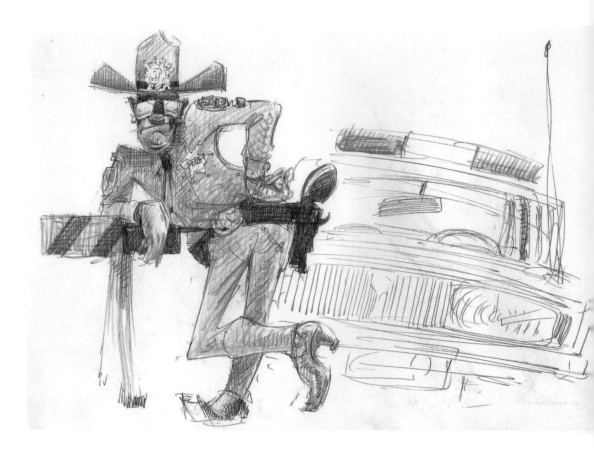

Since my chance experience of being my subject as I drew, my simple findings have had a profound impact on my approach to everything I draw. I combine breathing and timing in much the same way that actors, dancers or musicians apply phrasing to their performance. My inner impulses change to deliver an appropriate outer mark (effort) to fit my subject. Before I begin to draw I look at my subject and then make a rapid inner assessment to distil a number of things about it: the three-dimensional area or space it occupies, its weight and its flow, referring to its energy and its surface textures. Do I need to work tight or free, and how do these efforts enhance my subject as a whole?

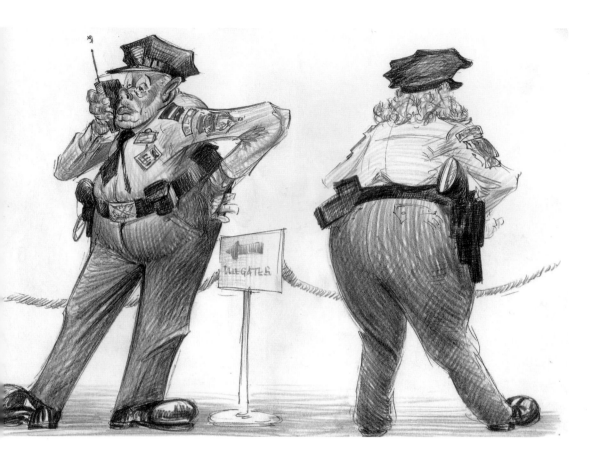

This method allows me to explore my drawing in a very special way. I exercise a measured control throughout my entire being to help me to focus my realization of space – my journey across and around my subject as I experience its form, texture and, above all else, its pulse.

These drawings of Texan security officers demonstrate attitude, weight and gestures appropriate to their professions. They may appear to be comic caricatures, but they are anatomically correct. The coloured pencil strokes echo the structure and volume of each character.

You're Safe with Us
Fine-point pen and coloured pencil, 1989
21 x 58cm (8¼ x 22¾in)
As always, in these drawings I let my tools speak for me.

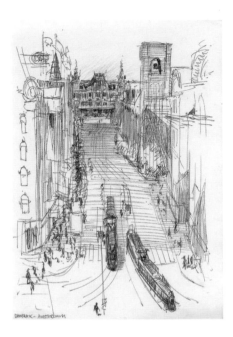

Amsterdam Central Station
Fine-point pen and coloured
pencil, 1990
21 x 29cm (8¼ x 11½in)
The bright sunlight catching
Amsterdam Central Station is
the focal point of this drawing.

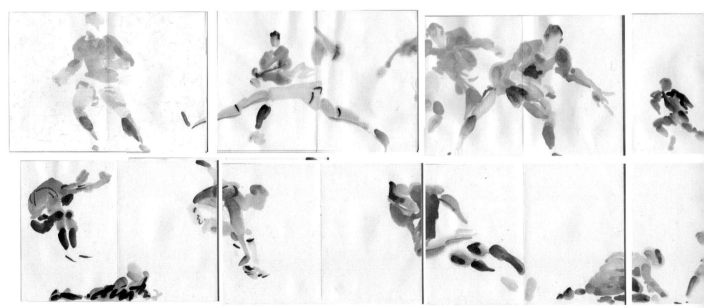

In my drawing of Amsterdam Central Station (opposite) I have left the fine-point pen lines to assume the role of detailing the other buildings and the yellow streetcars to add weight to complete the foreground. This is a speedy method of noting the atmosphere of a place, with a high perspective adding additional energy to the composition. Energy is another vital component in a drawing, but it need not be detailed – it can rely only on body language or rhythm for its effect.

A good way to begin to capture and understand energy is to draw from the sports pages of newspapers. It is easier to see the broad action at work, without being distracted by unnecessary details. Look closely at the pose for its energy. This boldly painted football game does just that: not a boot lace or hair implant in sight – just action! Capture the line of action running through the body of the figure before paying any attention to further detail.

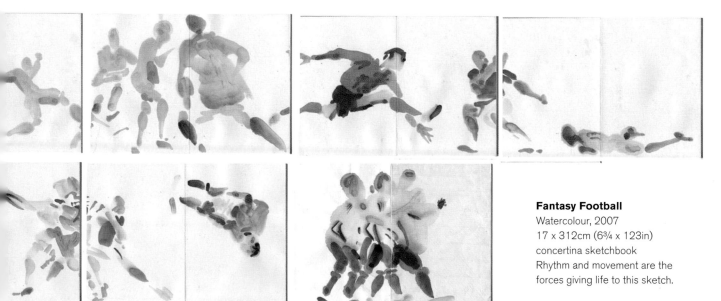

Fantasy Football
Watercolour, 2007
17 x 312cm (6¾ x 123in)
concertina sketchbook
Rhythm and movement are the
forces giving life to this sketch.

To catch a figure in motion, the sculptor Auguste Rodin maintained that the only solution was to combine one pose in two different phases of the same continuous movement.

Here the action of the dancer turning is analysed in a sequence of layers for animation: each drawing springs from the previous one, anticipating the next move.

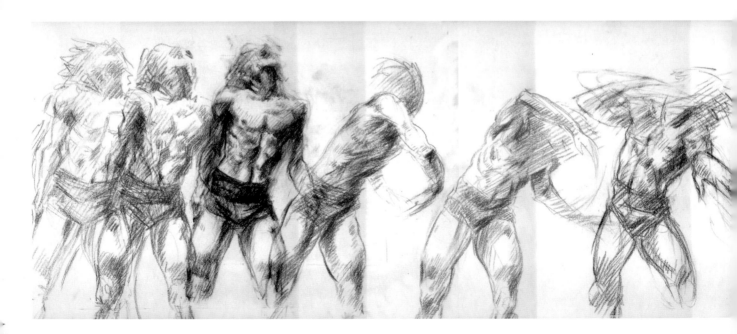

I filled a sketchbook with drawings of dancers and the result prompted me to make an animated film. This gave me an opportunity to demonstrate my drawing theory for the visual arts combined with that of Rudolf Laban's analysis of movement for the performing arts as described on pp.34-5. When you make drawings of figures in movement, it is important to inwardly realize and anticipate every stage of the action as you draw. Each drawing should show something of its past, its present and its future.

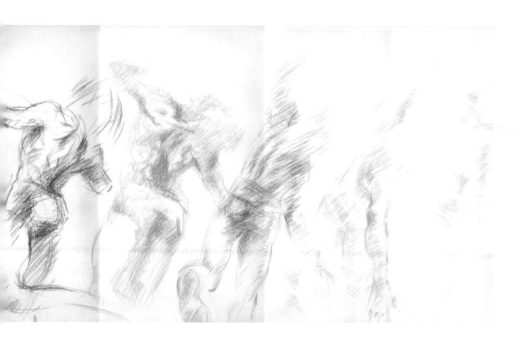

Animated film drawings, 'Summer Dream'
Conté chalk, 2012
24 x 363cm (9½ x 143in) (composite of 11 drawings)
Throughout I maintained my vision of the space in which my drawings would materialize.

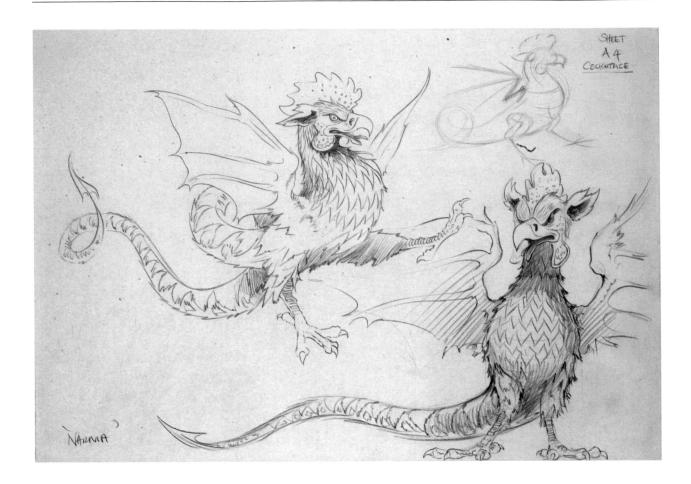

The importance of observational drawings from life cannot be overestimated, as they add credibility and energy to fantasy drawings made from the imagination.

You must experience the living attitude of your characters as you draw them. The heraldic cockatrice and the eerie phantom shown here are amalgams of animal and human anatomy and tree roots: fact becomes fiction, fiction becomes reality.

Cockatrice
2B pencil, 1987
42 x 58cm (16½ x 22¾in)
A creature may be mythical but for you to draw it, it must exist in your head.

Ghoul
2B pencil, 1987
42 x 58cm (16½ x 22¾in)
Allow your mind to become one
with the characters you draw.

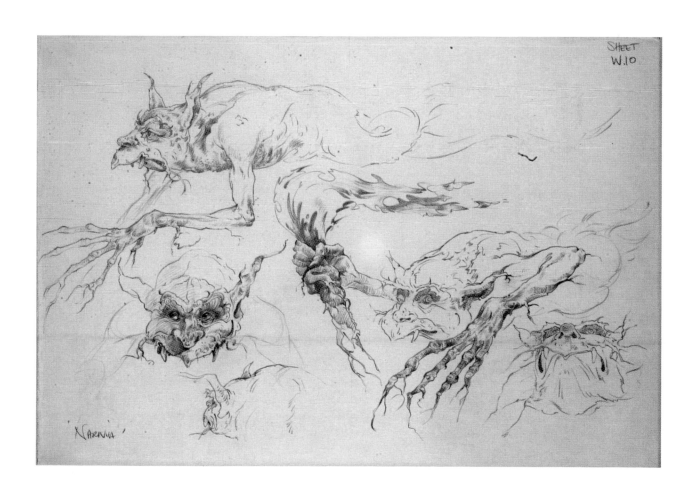

I enjoy the movement and rhythm in this composition, feeling the breeze as it moves through the trees, catching the swings as they pass. The concrete post in the foreground plays a wonderful part in adding stability to this rhythmic drawing. As you draw, become the air, the light and the textures.

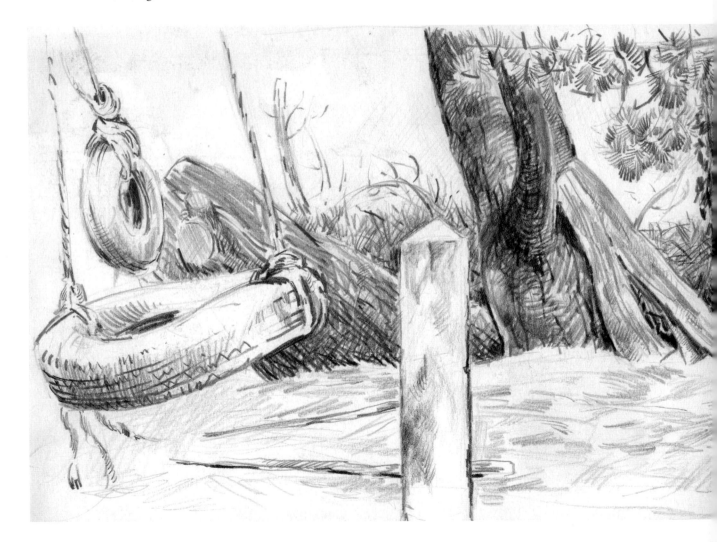

As you become familiar with the way you assess and apply your breathing and timing to your drawing, you will gain a greater enjoyment from your drawing performance.

Garden Swing
Coloured pencil, July 1990 21 x 58cm (8¼ x 22¾in)
Envisage the subject on your page as you continue to draw.

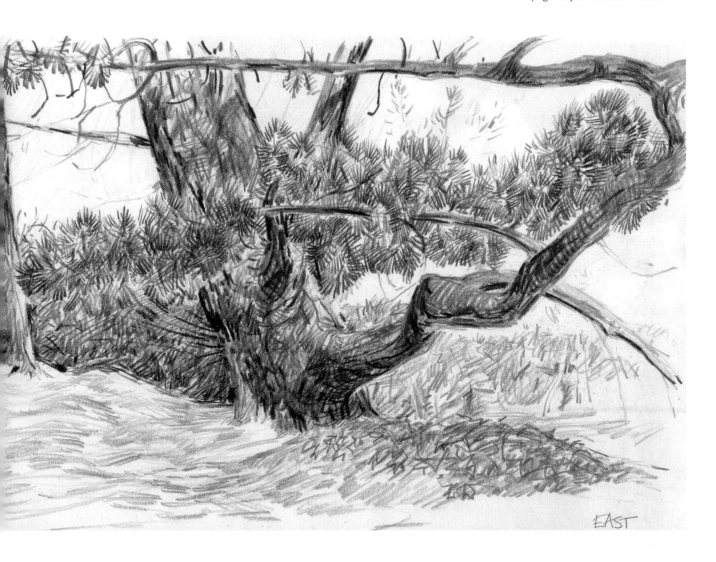

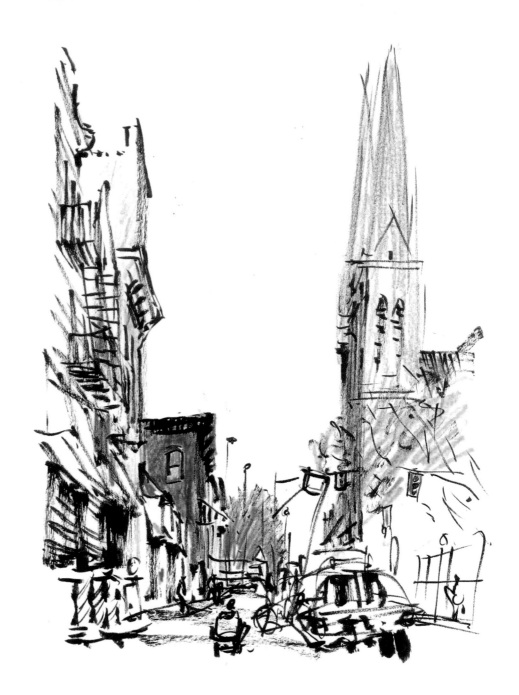

NYC, Montrose Ave
Brush pen and coloured
pencil, 2012
21 x 29cm (8¼ x 11½in)

MAKING A PICTURE

Rise to every occasion

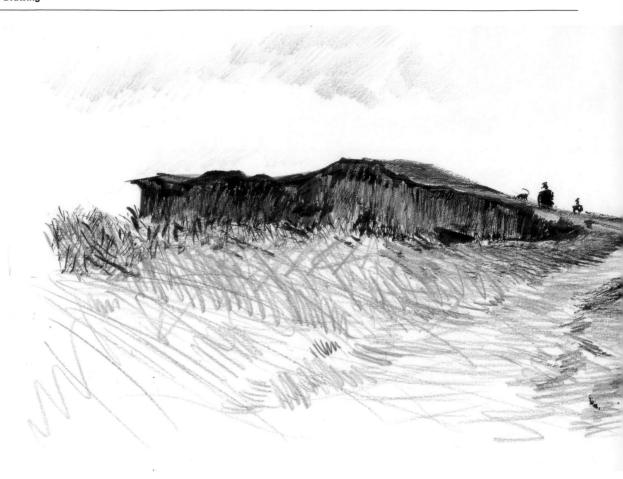

By adding four more ingredients to image-making, this chapter
completes all we have shared in the previous pages. They
are perspective, balance, composition and narrative:
the thoughtful placing of a drawing on the page, using
judgement to excite tensions and therefore interest.

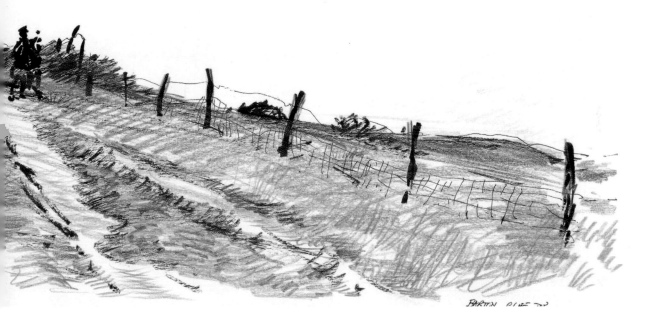

Perspective need not be complicated. To put it simply, it is foreground large, distance small, allowing us to reach into the page. Dramatic effects are achieved when is made very obvious. I look at my subject to see foreground against distance and natural perspective becomes evident. The eye catches what is of most interest; this becomes the focal point, or main attraction. As for the surroundings, in my peripheral vision, objects are less detailed; they take second place in favour of the focal point. Look at any object and your eye will naturally give it focus, while the surrounding area is less focused.

Brooding Cliff-top
Brush pen and coloured pencil, 2005
21 x 58cm (8¼ x 22¾in)
In this drawing your eye is led up the track to the dark cliff edge, then settles on the figure silhouetted against the skyline.

In Malta, I looked at the town of Mellieha across a steep ravine and was struck by the pattern made by the rectangular buildings. A traditional perspective was nowhere to be seen. Faced with the prospect of drawing a whole townscape, I reverted to the simplest method – a decorative pattern with an enlarged insert to show the house with the most

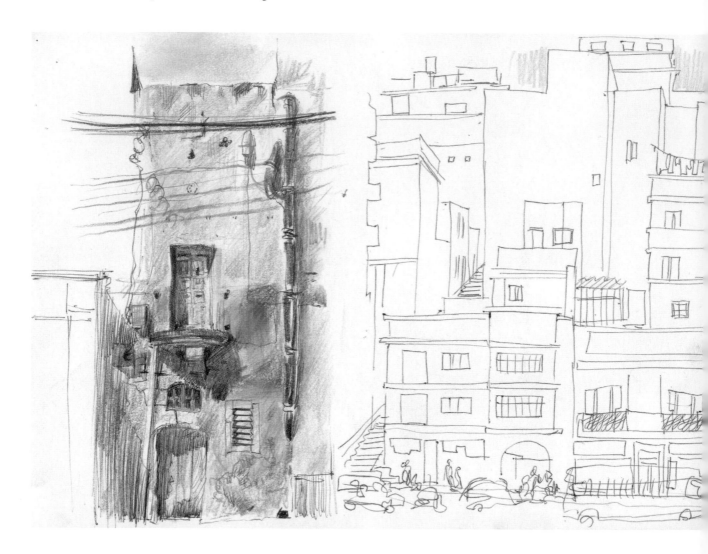

interest. For the most part I followed the shapes of the buildings in a simplified form, and then chose one shop front for its colour and texture to bring out the essence of Mediterranean town. Everything else is secondary.

My prime tip is to draw what you see and feel – and above all, have fun!

Mellieha, Malta
Fine-point pen and coloured pencil, 1996
21 x 58cm (8¼ x 22¾in)
The town is just an impression, but the insert is correct.

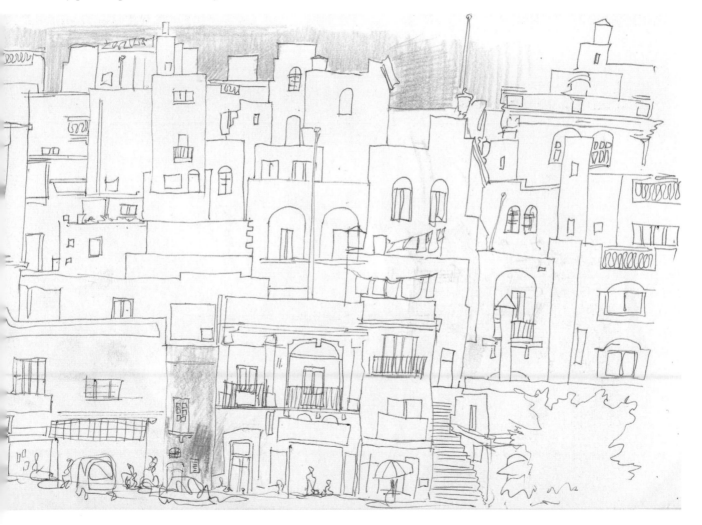

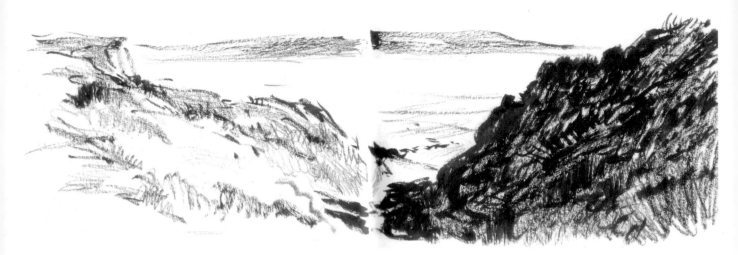

The images on these pages are examples of aerial perspective, where the density of the atmosphere causes tone and colour to become progressively more muted as objects recede from the viewer.

The island in the distance is the focal point in this drawing, emphasized by the deep ravine cutting through the foreground. The dramatic dark bank on the right gives way to the middle tones of the left bank while the trickling stream between the two leads your eye to the island.

My watercolour sketch of Lake Maggiore, Italy, reverses the position of the focal point. Though they lack any detail, the focal point of the dark muted wooden piles in the foreground drives a dramatic perspective into the picture by making a contrast to the paler impressionistic colours of the distant background. The very nature of a focal point is that it dominates the picture, seizing the viewer's eye.

The Isle of Wight
Brush pen and chinagraph pencil, 2001
21 x 58cm (8¼ x 22¾in)
To gain impact, don't be afraid to use a full range of tones from black to white as I have done here.

Lake Maggiore, Italy
Watercolour, 2001
21 x 29cm (8¼ x 11½in)
The tonal contrast from dark to
light colours focuses the eye
without the need for detail.

In selecting images from my sketchbooks for this book, I have made no attempt to crop or reconfigure the original drawings. I have purposely included the centrefold of each sketchbook to illustrate my working method. Before I start to draw I consider the available format of the page. For me, this is where compositional design begins: where to place things on the page.

Although the massive decorative parliament building dominates this image, the drawing remains finely balanced – the scales are evenly loaded. The equilibrium of the composition relies on the proportions of the blank white paper and the black brush pen drawing to tell the story of the city of Budapest, once two separate cities on opposite banks of the Danube.

The Hungarian Parliament Building, Budapest
Brush pen and chinagraph pencil, 2009
21 x 58cm (8¼ x 22¾in)
A cluster of dots and dashes is enough to interpret distant fine detail or create a focal point.

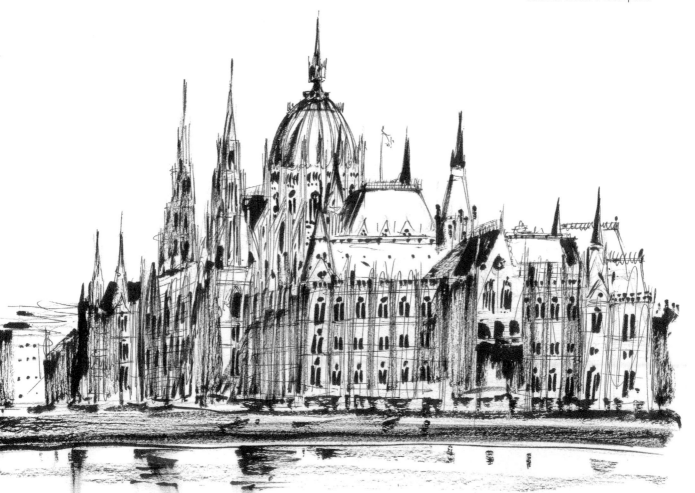

These three maritime images each show distinctly different approaches to compositional design and narrative. While the focal point is clear in each drawing, the eye is taken on a journey by the prioritizing of the details.

The detail on the small Chinese houseboat is very closely observed; great attention is given to the building materials. It is first and foremost an information drawing. In my second drawing, *Freeport*, I was caught not just by the colour, but by the textbook demonstration of one-point perspective through the portside cranes. Finally, the complementary colours of *Puerto Colon, Tenerife* and my loose handling of watercolour induce pleasure and freedom. Therefore, your choice of medium and drawing technique is important in bringing out the character of your subject.

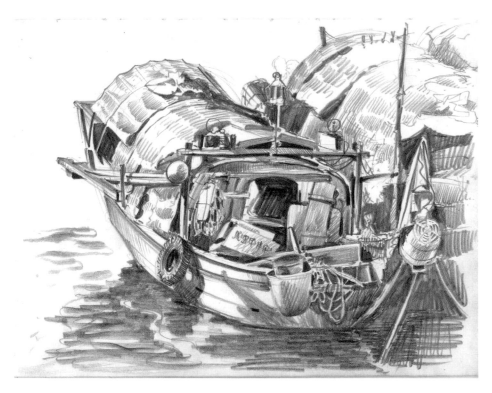

Typhoon Anchorage, Hong Kong
2B pencil, 1980
18 x 24cm (7 x 9½in)
Here, interpretive marks derive from intense observation.

Puerto Colon, Tenerife
Watercolour, 1996
21 x 29cm (8¼ x 11½in)
Free flow colour patterns.

Freeport
Coloured pencil, 1986
21 x 29cm (8¼ x 11½in)
A statement of bold
linear colour.

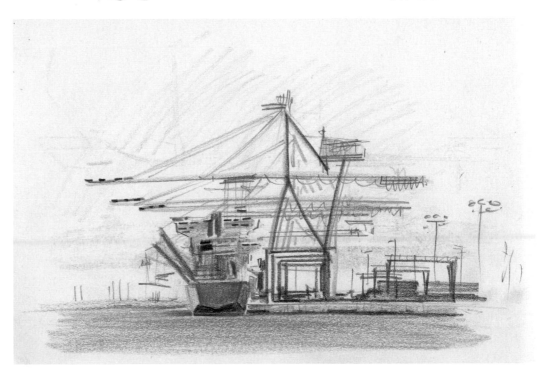

As you have seen previously, dramatic effects can be achieved simply and effectively when perspective is made obvious: foreground large, distance small.

Simple shapes and muted colours make up the appeal of this 11th-century castle. Even though it is only a rapid watercolour sketch made in a sketchbook, the double page spread plays a vital part in the overall design. The looseness of the watercolour adds to its overall romance.

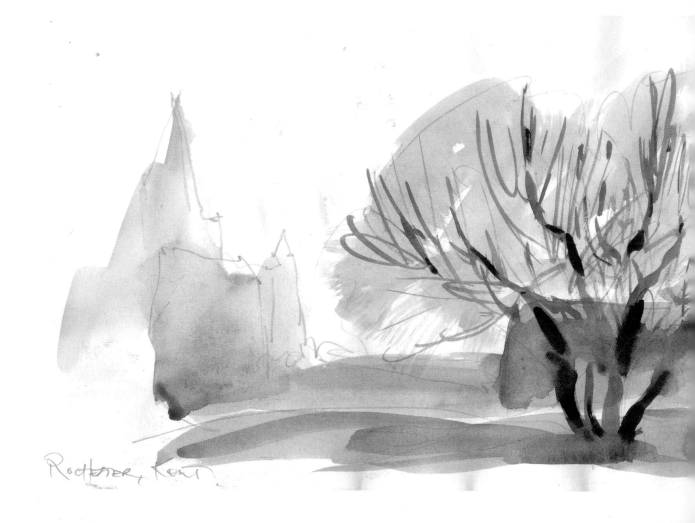

Rochester Castle, Kent
Pencil and watercolour, 2003
21 x 58cm (8¼ x 22¾in)
A minimal pencil sketch
established the composition in
preparation for a free-flow dash
of wet-on-wet watercolour.

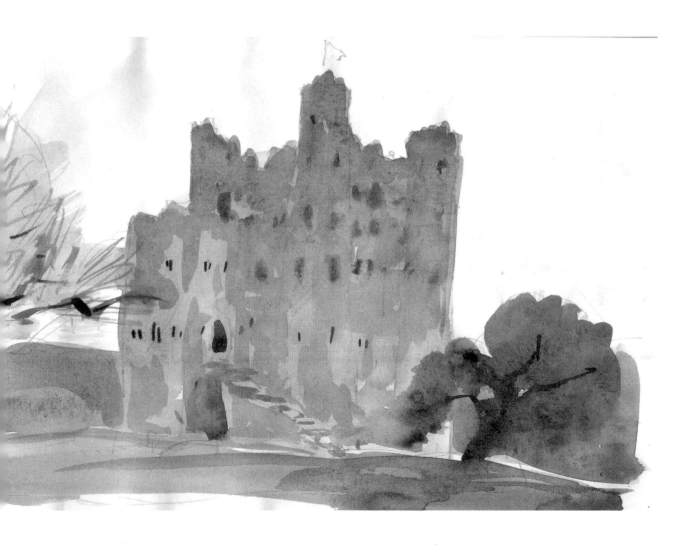

Fortuneswell is the centre of the Isle of Portland's yearly cycle of activities. Thomas Hardy, in his novel *The Trumpet-Major*, describes the village as the 'Street of Wells' and on the day I visited the annual November fair the heavens opened, threatening to wash everything away. After one particularly heavy downpour, I closed my sketchbook in despair and squirted my watercolour sketch out onto the street!

Rain before the Fun
Stick, waterproof ink and watercolours, 1995
35 x 50cm (13¾ x 19¾in)
A light paint line holds the image in place for a very free play of colour.

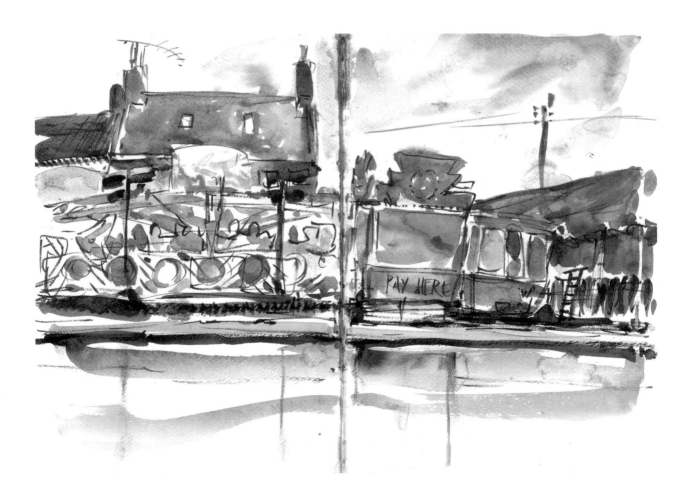

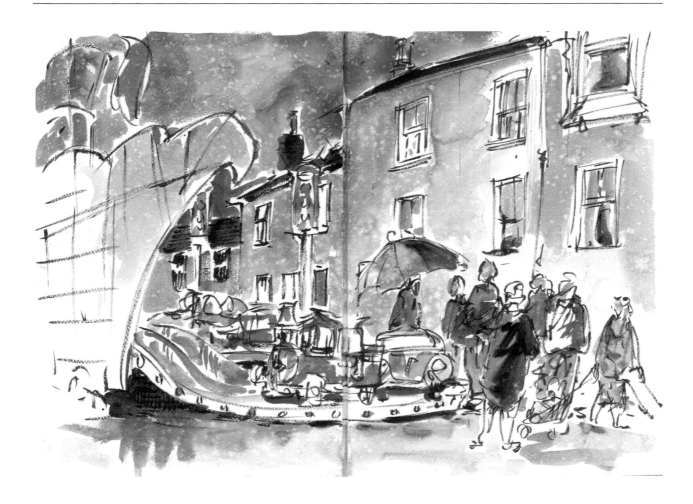

At last the musical rattle of the Chiswell Street Fair got underway, entertaining the local children and their families, who remained impervious to the rain – which can be seen adding its own organic magical texture to my sketch. Watercolour is famed for its happy accidents!

Chiswell High Street, Fortuneswell Fair
Stick, waterproof ink and watercolours, 1995
35 x 50cm (13¾ x 19¾in)
Intense complementary colours capture the rainy evening light.

**Sweetheart Abbey,
Dumfriesshire**

Brush pen and
watercolour, 2014
21 x 58cm
(8¼ x 22¾)

A GROWING ARCHIVE

From the back to the front

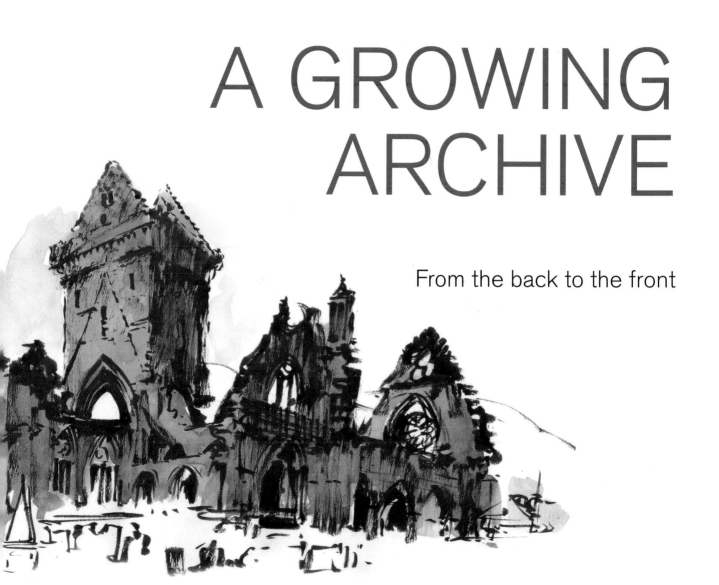

Throughout the chapters of this book I have tried to share what stimulates my measured approach to drawing. An approach to spatial awareness of mark-making that deepens my connection both physically and mentally to my subject – a process that is continually renewing.

Drawing begins with our eyes, which stimulate and engage us with an important inner experience which, in turn, prepares us for the outer action of drawing. I believe we should think of seeing as a part of a performance involving our whole being, reinvigorating our senses that put us in touch with the elemental forces of nature.

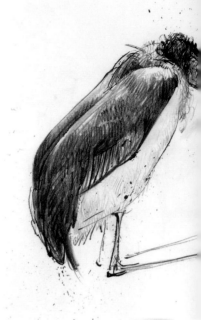

Marabou Stork
Quill pen and coloured pencil, 2010
42 x 59cm (16½ x 23¼in)
Take advantage of the whole page spread when you have a subject that warrants it, as I did here.

Chesil Beach, Portland, England
Watercolour, 1979
21 x 58cm (8¼ x 22¾in)
Composition, colour and the sense of sea air make this picture a success.

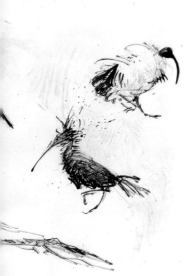

Café
Brush pen, 2009
21 x 29cm (8¼ x 11½in)
Body language expresses the
thoughts of this pair.

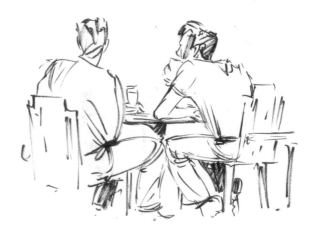

Lockhart, Texas, USA
Brush pen and watercolour,
2010
21 x 29cm (8¼ x 11½in)
This is a quick sketch with
free colour notes.

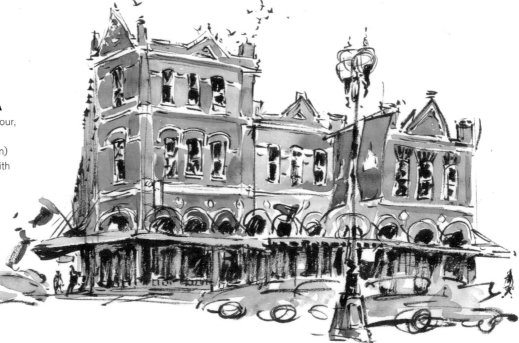

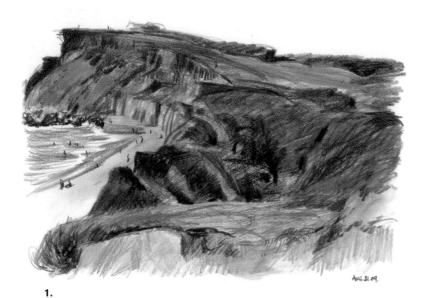

1.

2.

1. Barton Cliffs, England
Coloured pencil, 2001
21 x 29cm (8¼ x 11½in)
Vibrant colour sculpts the
landscape.

2. The Louvre, Paris, France
Chinagraph pencil and brush
pen, 2002
25 x 50cm (10 x 19¾in)
Textures of glass and stone are
set behind crowds of people.

3. Generator, Portland Fair
Coloured pencil, 1987
21 x 29cm (8¼ x 11½in)
A direct use of colour for energy.

4. Annecy, France
Brush pen and ballpoint pen,
2009
29 x 21cm (11½ x 8¼in)
Brush marks catch the
movement.

5. Old Budapest, Hungary
Brush pen and coloured pencil,
2003
21 x 58cm (8¼ x 22¾in)
Spirited brush drawing and local
colour seize the day.

3.

MUSÉE du LOUVRE.

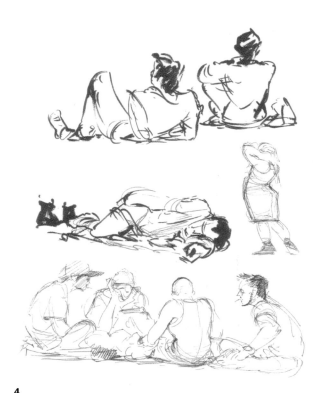

4.

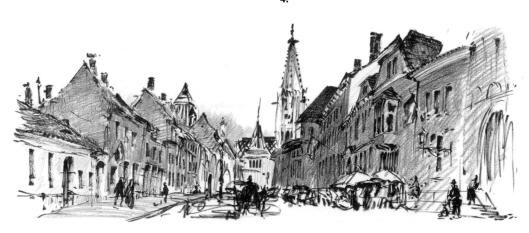

5.

One of my students, a scientist by profession, said, 'Since I've been attending your classes, I've discovered the sky! I've always known it was there, but I'd never seen it before.' Obviously he had looked at the sky every day, but his epiphany came when he recognized that looking had become seeing, which brought meaning to his drawing.

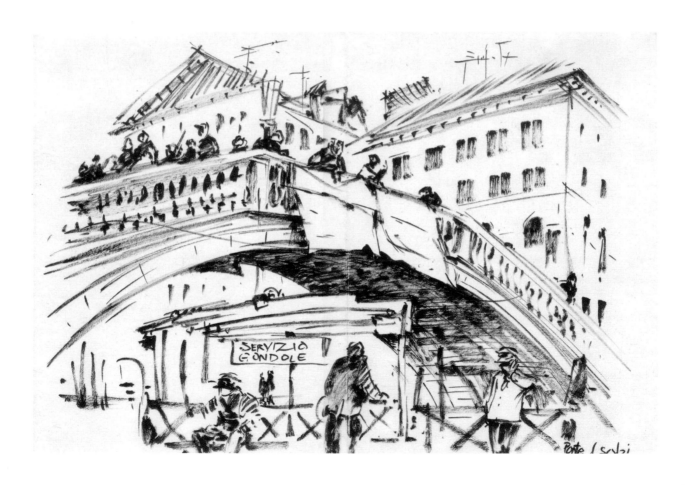

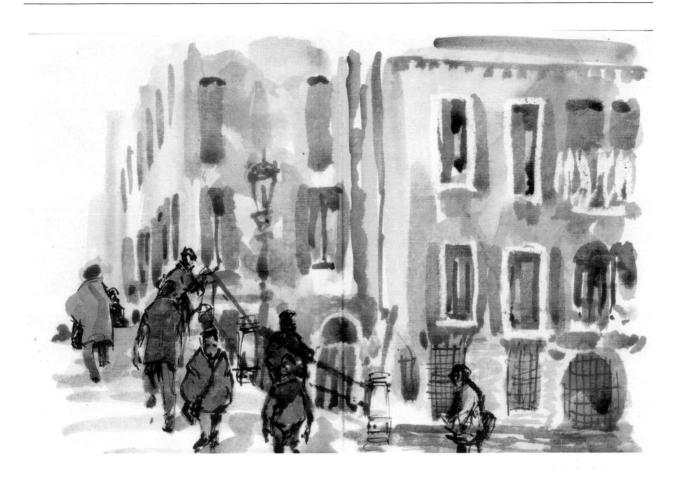

My final tip: Draw what you see and have fun!

Ponte degli Scalzi, Venice
Brush pen, 2007
21 x 25cm (8¼ x 10in)
A constructive use of light and
shade bridges the Grand Canal.

Campo San Moise, Venice
Watercolour and brush pen,
2007
21 x 25cm (8¼ x 10in)
Free-flow wet-on-wet
watercolour breathes life and
energy into this sketch.

INDEX

A

Action 28, 55, 122, 138, 140,145, 146, 147, 170
Actions 34, 35, 36
 direct 36
 indirect 35
Actor 13 29, 35, 142
Anatomy 37, 47, 80, 82, 83, 92, 118, 143,148
Animals 74, 85, 136
Animation 146
Antennae 29, 39, 116
Archive 12, 169, 171, 173
Architecture 21, 45, 121, 136, 138
Architectural 18, 90
Art, artist 18, 19, 21, 34, 35, 36, 45, 46, 48, 51, 56, 88, 100
Attitude 28, 36, 41, 122, 141, 143, 148

B

Balance 52, 90, 154, 161
Brain 30
Brassaï, Gyula Haláza 46
Breathing 27, 28, 58, 70, 119, 136, 142, 151, 170
Brush pen 41, 48, 51, 58, 59, 76, 88, 90, 101, 108, 117, 161, 172, 175

C

Children 10, 34, 167
Chinagraph pencil 45, 74, 76, 158, 161
Colour(s) 10, 15, 17, 19, 45, 52, 53, 56, 57, 60, 69, 72, 73, 93, 94, 95, 96, 104, 105, 107, 109, 110, 111, 134, 157, 158, 159, 162, 163, 164, 166, 167, 170, 171, 172
Colour pencil 9, 28, 29, 38, 40, 41, 47, 52, 53, 54, 56, 57, 72, 100, 101, 134, 143, 144, 152, 155, 157, 170, 172
Composition 46, 52, 145, 150, 154, 160, 161, 162, 165, 170
Conté chalk 46, 47, 80, 81, 82, 83
Copy, copying 46, 47

D

da Vinci, Leonardo 46, 51

Dance

Dance 8, 27, 82, 98, 135, 136 142, 147
Digital 102, 107, 108, 109, 110
Distance 52, 86, 155, 158, 164
 distant 158, 161
Drama 8 65, 76, 136, 158, 164
Drapery 72, 80, 136
Drawing 8, 10, 13, 18, 20, 21, 23, 25, 28, 29, 30, 31, 32, 35, 36, 39, 40, 45, 46, 48, 49, 50, 51, 52, 53, 54, 55, 57, 58, 59, 60, 65, 74, 78, 80, 82 89, 91, 93, 94, 95, 96, 97, 98, 100, 101, 102, 105, 110, 114, 116, 117, 118, 119, 122, 124, ,126, 130, 136, 140, 144, 145, 146, 147, 148, 150, 151, 154, 155, 158, 160, 161, 162, 170, 172, 174

E

Efforts 35, 36, 37, 48, 49, 55, 58, 60, 70, 78, 83, 95, 96, 114, 142 (also see Laban)
Emotion 29, 39, 136, 161
Energy 16, 76, 82, 88, 96, 136, 138, 140, 142, 145, 148, 172, 175
Epiphany 174
Essence 56, 88, 140, 157
Experience 9, 19, 29, 30, 37, 39, 40, 80, 107, 119, 122, 124, 136, 141, 142, 143, 148, 170
Expression 30, 48, 138
Eye 12, 13, 29, 30, 49, 52, 53, 59, 60, 70, 104, 114, 116, 118, 128, 136, 151, 155, 158, 159, 162, 170
 mind's eye 118, 128, 151

F

Fantasy 148
Fauvist movement 56
Fiction 148
Focal point 52, 144, 155, 158, 161, 162
Foreground 129, 145, 150, 156, 158, 164
Fun 20, 21, 60, 96, 157, 175

G

Gesture 76, 138, 141, 143
Graffiti 12
Graphite sticks, pencil 78, 79, 80

H

Hand, handling, handled 14, 16, 30, 45, 56, 74, 85, 86, 116, 118, 120, 122, 124, 136, 139, 162
Hardy, Thomas 166
History 28, 32, 33, 51, 82, 114, 116
Humans 12, 74, 82, 148

I

Illustration, illustrate 8, 160
Imagine 33, 36, 40, 72
Imagination 51, 140, 148
Impression 16, 33, 48, 104, 131, 157, 158
Ink 42, 68, 87, 96, 97, 98, inky 101, 127, 141, 166, 167
Inner, actions, impulses 36, 70, 142
iPad 9, 64, 68, 102, 104, 106, 107, 108, 109, 110, 111
Instinct 10, 12
Intuitive13

J

Judgment 154

K

Kollwitz, Kathe 46, 47

L

Laban, Rudolf 34, 35, 49, 58, 60, 95, 96, 115, 118, 147
 notation of efforts 49, 58, 96,
Landscape 136
Life 75
 life forces 137, 139, 141, 143, 145, 147, 149, 151
Light 36, 38, 39, 47, 50, 52, 56, 58, 61, 72, 73, 74, 80, 85, 86, 100, 107, 110, 121, 122, 123, 125, 127, 129, 130, 150, 159, 167, 176
 highlights 56, 80, 87, 125, 141
Line 30, 32, 37, 39, 40, 43, 45, 47, 50, 53, 71, 80, 85, 86, 87, 88, ,92, 96, 98, 104, 115, 116, 117, 118, 119, 120, 126, 128, 130, 132, 133, 145, 166
 line of action 138, 145
 line of life 140
Linear 116, 121, 163
Location 45, 56, 79, 88, 101, 104, 110, 138
Look 8, 29, 45, 68, 70, 90, 93, 96, 140, 141, 142, 156
 looking 9, 46, 60, 93, 174

M

Mark 10, 27, 31, 36, 39, 40, 46, 47, 53, 59, 60, 64, 68, 70, 82, 86, 90, 96, 98, 117, 120, 172
 mark making 8, 25, 34, 35, 36, 45, 46, 53, 54, 68, 74 , 83, 93, 96, 98, 102, 122, 170
Masters 46, 47, 49
Measured 56, 83, 143, 170
Meditation 10, 52, 70
Memory 10, 21, 45, 50, 89, 124
Modulations 36, 114
Musicians, music-making 27, 142

N

Narrative 29, 140, 154
Nature 30, 36, 41, 51, 54, 95, 96, 98, 107, 122, 130, 158, 170
Newspaper 145
Notes, note-taking 52, 72, 74, 109, 171
 notation – 34, 35, 49, 58, 96, 118

O

Object 29, 39, 61, 118, 156, 158
Observe 21, 107, 108, 110, 111, 116, 125, 136, 162
 observational 8, 46, 59, 70, 148
Oil pastel 92, 93, 100
Optical, optical effects 53, 54, 72
Outer actions 28, 35, 36, 122, 140, 170
 outer expression 36, 70, 96

P

Paper 9, 10, 29, 40, 51, 74, 80, 82, 87, 90, 97, 100, 102, 118, 122, 125, 161
Patterns 59, 123, 125, 126, 163
Pen(s) 9, 18, 30, 41, 42, 48, 51, 52, 58, 62, 69, 76, 86, 88, 89, 90, 96, 97, 98, 100, 108, 117, 118, 120, 122, 128, 130, 134, 139, 144, 145 152, 156, 157, 158, 161, 169, 170, 171, 172, 175
Pencil 8, 9, 10, 143, 148, 149, 162, 165
Performance 36, 48, 74, 82,142, 151, 170
 performing 34, 36, 147
Perspective 78, 130, 146, 155, 156, 158, 162, 164
 aerial perspectives 158
Phrasing 25, 58, 114, 118, 142 (also see time)
Physical 40, 98, 140, 170
 physicality 93
Poetic 95
Preparation 28, 35, 36, 80, 96, 98, 165
Putty rubber 78, 79, 85

Q

Quill pen 30, 69, 96, 98, 170

R

Read 18, 33, 45, 47, 123
 reading 47, 48, 49, 59
Realise 34, 46, 97, 98, 118, 147
Reality 10, 124, 148
Rectangular 156
Rembrandt 47
Research 46, 48, 51
Rhythm 82, 85, 136, 138, 140, 145, 150
Rodin, Auguste 51, 146
Rubens, Peter Paul 46

S

Scribble 12, 87, 128
Scrutiny 18, 47, 114
Sculpt 49, 87, 128, 172
 sculptor 50, 51
 sculptor 146
 sculptural 74, 82, 98, 136
 sculpting 74, 78
Seeing 9, 51, 70, 120, 128, 170, 174
Senses 8, 12, 29, 30, 39, 70, 83, 110, 114, 116, 119, 120, 136, 138, 170
Sketchbook 8, 10, 12, 13, 14, 16, 18, 20, 45, 50, 56, 65, 82, 91, 107, 108, 109, 140, 145, 147, 160, 164, 168
Sketching 52, 68, 85, 91, 97, 110
Smudging 79
Space 8, 32, 36, 52, 56, 82, 98, 118, 120, 122, 123, 142, 143, 147
Stanislavski, Constantin 29
Story 117, 140, 161
Strokes 37, 39, 58, 82, 86, 104, 130, 132, 136, 138, 143
Style 45, 47
 free-styles 16, 56
Subject 19, 28, 29, 30, 36, 37, 39, 45, 46, 47, 50, 52, 54, 60, 70, 72, 82, 85, 93, 97, 98, 101, 114, 116, 117, 119, 123, 124, 126, 129, 132, 136, 140, 142, 156, 162, 170
Surface 28, 36, 39, 40, 41, 53, 60, 116, 124, 128, 136, 142

T

Texture 29, 30, 36, 39, 40 53, 56, 59, 60, 70, 74, 80, 85, 90, 101, 107, 108, 109, 114, 115, 118, 121, 122, 124, 126, 132, 142, 143, 150, 157, 167 172
Time, timing 8, 10, 13, 20, 23, 29, 30, 36, 48, 52, 56, 57, 59, 70, 74, 76, 109, 118, 120, 121, 125, 127, 132, 136, 140 158 (also see phrasing)
Tools 63, 64, 65, 68, 70, 72, 74, 80, 86, 88, 93, 94, 96, 100, 101, 102, 110, 114, 143

V

Van Dyck, Sir Anthony 46
Visual, visualisation 13, 33, 34, 36, 118, 147

W

Watercolour 18, 23, 28, 30, 31, 45, 56, 57, 65, 66, 69, 93, 94, 95, 96, 100, 101, 138, 139, 145, 158, 159, 162, 163, 164, 165, 166, 167, 168, 170, 175
Wax, wax crayons 10, wax resist 69, 93, waxy oil pastels 92, wax pencil 74, wax clay 80